IMAGES
of America

POST

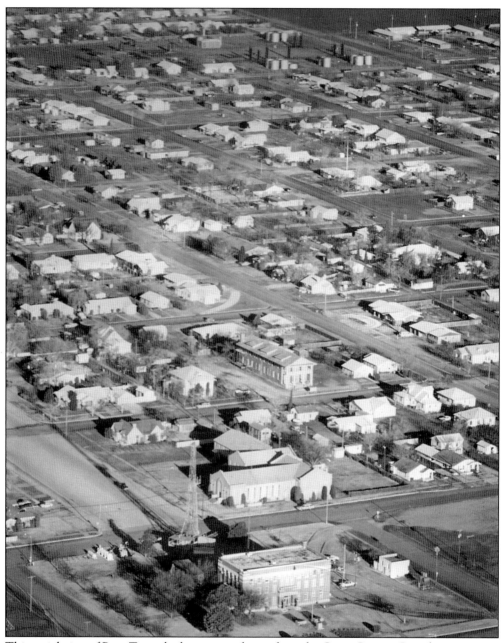

This aerial view of Post, Texas, looks west-northwest from the Garza County Courthouse square. The two-story stone building in the center of the photograph is the Garza County Historical Museum, the central conservation location for the history of Post and Garza County. (Courtesy Garza County Historical Museum.)

ON THE COVER: Post family members look smashing as they gather on the rear platform of C.W. Post's private railroad car for this c. 1908 photograph. Pictured here are, from left to right, Dorothy Howe (family friend), Mollie Post (wife of Carroll Post), Rollin Post (C.W.'s father), Carroll Post (C.W.'s brother), Caroline Post (C.W.'s mother), C.W. Post, and Leila Post (wife of C.W.). (Courtesy Bentley Historical Library.)

IMAGES of America
POST

Linda Puckett

Copyright © 2013 by Linda Puckett
ISBN 978-0-7385-9630-3

Published by Arcadia Publishing
Charleston, South Carolina

Printed in the United States of America

Library of Congress Control Number: 2012947001

For all general information, please contact Arcadia Publishing:
Telephone 843-853-2070
Fax 843-853-0044
E-mail sales@arcadiapublishing.com
For customer service and orders:
Toll-Free 1-888-313-2665

Visit us on the Internet at www.arcadiapublishing.com

To the memory of Charles William Post, a man who cared about the other fellow, and to those men and women of all branches of the military and law enforcement agencies who risk it all to protect us.

Contents

Acknowledgments		6
Introduction		7
1.	C.W. Post, the Texan	9
2.	A Town For the People	17
3.	Strollin' Down Main Street	31
4.	Life Below the Cap	41
5.	Standing on the Promise	73
6.	The Ups and Downs of Gettin' Around	77
7.	Post Sanitarium 100 Years Ago	93
8.	C.W. Post Historical Center	103

ACKNOWLEDGMENTS

The history of Post City, Texas, can be found in the archives of the Garza County Historical Museum (GCHM), which is housed in the old Post Sanitarium building constructed by Charles William (C.W.) Post 100 years ago in 1912. It has been my great honor to have served as the director/curator for the museum for the last 18 years. The earlier works by the Garza County Historical Survey Committee, who are all gone now, were invaluable to what I was able to achieve, and their service and dedication will never be forgotten. C.W. Post is a key aspect to everything that I do at the museum—my palette for the scene that I keep painting to tell the history of Post and Garza County. All photographs used in this publication are from the archives of the Garza County Historical Museum or otherwise indicated.

Special thanks to my pal JoAnn Mock, who put me on this trail; the Garza County Commissioners Court; the Post-Montgomery families; local donors; the Maxine Durrett Earl Charitable Foundation; the E.A. Franklin Charitable Trust and the late Giles C. McCrary; and the GCHM Board of Directors. Thank you all for your support and trust to do what I do and for never saying no; if you did, I did not hear you by choice. Thanks to Alvin and Barbara Davis and my assistant Pat Cruse; they share in my passion to preserve our history, and they understand that success doesn't always lie amid the best laid plans but in the discovery. And then there is C.W. Post, a real legend, a man with a dream and the means and a plan to accomplish it. The author's royalties from the sale of this book will go to the Garza County Historical Museum.

Thank you to all the families of the pioneers whose stories, photographs, and heirlooms have been donated to the museum. We hope we provide an opportunity for those of us left behind to experience some of their journeys.

Sincere thanks to Arcadia Publishing for allowing us to share this pictorial history of Post City, Texas.

INTRODUCTION

"Post" is a four letter word that became a trademark for food products that have occupied space in our pantries and at our breakfast tables for the past 118 years. Some men are just destined for greatness. It would seem that this man, Charles William Post, lassoed that title at a young age. He was a dreamer, inventor, industrialist, and entrepreneur.

An illness brought C.W. Post to the Battle Creek Sanitarium in Battle Creek, Michigan. After several months under the care of Dr. John Harvey Kellogg, Post had been given a virtual death sentence by the doctor, who was unable to find any successful treatment for Post's chronic digestive disorder. That diagnosis was unacceptable to Post, who later wrote, "I thought it over a good deal and came to believe it would be cowardly to quit then, with so much to do and so much responsibility, and I made up my mind I would not quit, but would finish the work I ought to do. I suppose I was a sight, but the only way I knew to get well was to be well, however I looked, and I began walking around like a man who had business to attend to." And that he did as he set about what he called his "Road to Wellville." Post devoted his spare time to proving the theories of the science of mind over matter, which he believed led to his successful recovery, prompting him to write a book, *I Am Well*, in 1894, and, later, *The Second Man*. The balance of his life was one success story after another.

Post purchased a small farm in Battle Creek, Michigan, where he established the La Vita Inn. It was on this site that Post would "father" the cereal industry in 1895, the result of his experimentation to develop a healthier food source to battle his personal health issues. From the beginning, Post's advertising of his products bore the slogan "There's a Reason." In a few short years, the Postum Cereal Company had made him a multimillionaire.

Post began to think about using a portion of his great fortune to help his fellow man help himself. Some time during 1905, he left the cereal company in the trusted hands of his brother Carroll Post and contacted veteran rancher Tom Stevens in Fort Worth, Texas, hiring him to locate desirable land in West Texas that would be the ideal sight for his colonizing venture and the building of his dream community. Through the years, Post had become well aware of social trends and the industrial and economic needs of our country, even getting politically involved with some of the problems facing our nation, such as the "Square Deal" of Pres. Theodore Roosevelt, and he was later known to associate with Pres. William Taft.

Post visited the Curry Comb Ranch lands in March 1906, accompanied by his wife, Leila, and his daughter, Marjorie. The party traveled by train to Colorado City, where they rented hacks to make the journey to the OS Ranch, where they were to be guests. The first night was spent at Gail, the seat of Borden County. Late in the evening of the second day, they arrived at the OS Ranch. Early the next morning, Post, Uncle Tom Stevens, and others rode a few miles around the Curry Comb lands, which consisted of 112,517 acres. Post purchased the ranch in June 1906.

OS Ranch manager Jim Clark had sent word to neighboring ranches that he was having a barbeque to welcome Post, and all were invited. The Litwalton correspondent for the *Lynn County*

News was in attendance. He reported that following the meal, Post was asked to speak; he spoke of his aspirations and dreams to the men and women seated in a semicircle on the ground. The reporter described Post's attire. He wore black cowboy boots, silver spurs, black corduroy trousers, and a maroon shirt, and in his hand was a white Stetson hat. He said he was endeavoring to get the Santa Fe Railroad Company to build through our new country and talked of starting a system of waterworks and an electric light plant. He said he was not talking in the air but meant what he said. The audience was somewhat skeptical, but as they would soon learn, C.W. Post meant what he said and could make things happen.

By October 1906, plans were set in motion, and for the next eight years, Post's hand controlled their every movement. Not only was Post building a town in the middle of Garza County, he was also creating a farming colony, experimenting with crops, irrigation, and industry, and fighting rain battles.

After the streets and blocks had been laid out, Post went back to Battle Creek and began an advertising campaign for his town. "Making Money in Texas" began to appear in major newspapers, and replies began piling into the Battle Creek office.

A new company, the Double U Company, was formed for the building and running of the new colony and incorporated on March 23, 1907. Post hired W.E. Alexander, a man with a variety of experience in building and farming and who had been in the lumber business in Oregon. Alexander arrived in Fort Worth on January 25, 1907, with instructions to set up a temporary office in the Fort Worth National Bank building. His job was to establish a temporary headquarters where men could be hired and arrangements made to transport materials and supplies to West Texas. A Fox typewriter was sent to him from Battle Creek, and he was authorized to engage a stenographer-bookkeeper. Alexander then closed the Fort Worth office, and he and the stenographer set out to Big Spring.

By the time they arrived, carloads of materials were coming in by train for the Double U Company. C.W. Post had sent Uncle Tom Stevens to Kansas City, Missouri, to buy mules. He arrived a few days ahead of Alexander, bringing with him 72 of Missouri's best mules. Post had sent 24 sturdy wagons and harnesses from South Bend, Indiana. Sam Wilks, an experienced mule skinner, was hired as wagon boss. When the 24 new wagons, their red wheels and green bodies shining in the sun, were all loaded and lined up on the Main Street of Big Spring, it was a sight that brought out the whole town. Loading the wagons took three days, and after another four-day journey to the new town site, they arrived on March 1, 1907.

This is our story: the town that Post built, Post City, Texas.

One
C.W. Post, the Texan

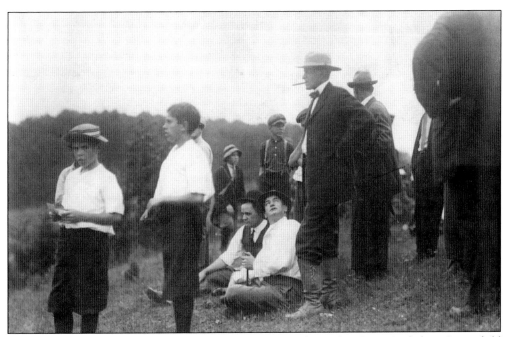

C.W. Post was no stranger to Texas. The Post family had relocated to Fort Worth from Springfield in 1887, seeking a milder climate. C.W. and his wife, Ella, arrived in 1888, after the birth of daughter Marjorie. The family settled on a small ranch of about 200 acres purchased by Post and Company. An illness would take C.W. Post to Battle Creek, Michigan—a life-changing event. (Courtesy Bentley Historical Library.)

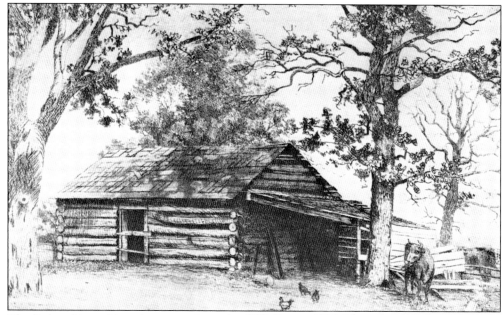

The little cabin etching above was drawn by C.W. Post in 1890. The cabin was located on the ranch property in Fort Worth. Post's artistic abilities were of use when he began designing cereal product boxes, containers, and advertising. He became quite a master at marketing his products; some say he fathered advertising.

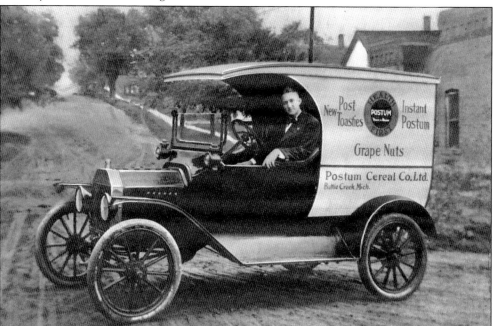

This Post delivery truck is serving two purposes, delivery and advertising "new" Post Toasties, which became available in 1906. The original product was called Elijah's Manna, but some voiced their dislike of Post using a Biblical name. He changed the name but fired back, saying, "Maybe no one should eat Angel Food cake, enjoy Adam's Ale, live in St. Paul, nor work at Bethlehem Steel." (Courtesy Bentley Historical Library.)

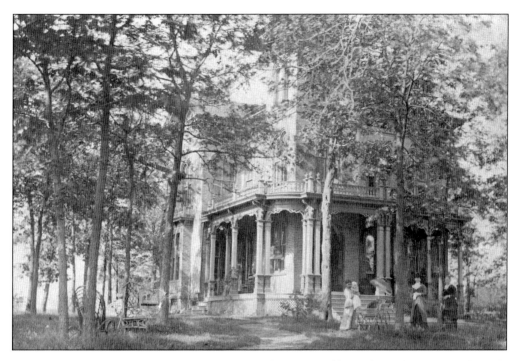

This beautiful large mid-Victorian house was purchased by Rollin and Caroline Post in the mid-1860s and was located on the corner of Black and Sixth Streets in Springfield, Illinois. This was the boyhood home of Charlie along with brothers Arrie and Carroll. It still stands today, just a few blocks away from the Abraham Lincoln home on Eighth Street. Marjorie Merriweather Post, C.W.'s daughter, was born in the house on March 15, 1887. The three Post ladies in the yard are unidentified, but the infant is probably Marjorie Post. The 1918 photograph below shows Rollin Post at the Los Angeles Ostrich Farm riding in a cart pulled by a very large ostrich. This man was a forty-niner; an ostrich wouldn't frighten him, even at this late stage of his life. He passed from this life on July 15, 1919, in Los Angeles. (Both, courtesy Bentley Historical Library.)

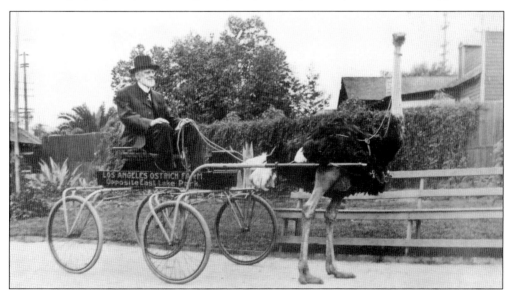

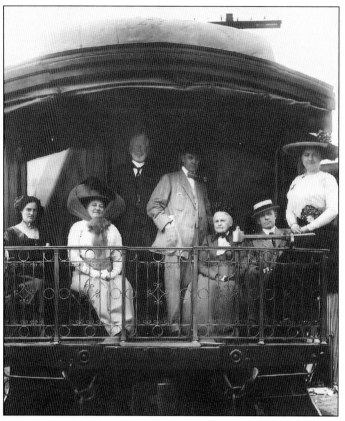

C.W. Post was a frequent traveler back and forth from Texas and Battle Creek or south to Mexico and back again to New York. Having a private car must have made those trips more enjoyable, especially with Mrs. Post and other guests on board. Those on the rear platform are, from left to right, Dorothy Howe, Mrs. Carroll Post (Mollie), father Rollin Post, Carroll Post, mother Caroline Post, C.W. Post, and Leila Post standing at right. Below is a view of the grounds of the Post Cereal Factory. When Post was in town and the private car was not in use, it was stored here in the tall garage or shed with the train track leading up to the door. The train station was just a couple of blocks away. (Both, courtesy Bentley Library.)

Marjorie Merriweather Post was the only child of C.W. and Ella Post. She married Edward Bennett Close on December 3, 1905, when she was 18 years old and he was 23. Together they had two daughters, Adelaide and Eleanor. The image at right shows Marjorie in her fabulous wedding travel dress and fur muff. Below, around 1918, Ed Close is sitting for a portrait with a very large portrait of wife Marjorie leaning against the wall. The artist is unidentified. The small community Close City is named in their honor. It is the location originally selected as the town site for Post City by C.W. Post. (Both, courtesy Bentley Historical Library.)

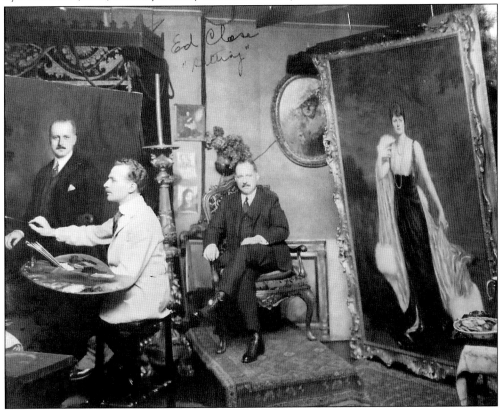

Caroline Lathrop Post, wife of Rollin Post, was a direct descendant of John Lathrop, who came to America in 1632, part of the Thomas Hooker clan seeking religious freedom. She was born on November 27, 1824, in Ashford, Connecticut. She and Rollin married on October 10, 1853, and together had three sons: Charles William Post, Aurelian Atwater Post, and Carroll Lathrop Post. Carrie was a writer of poetry, and her works were published in 1909 as *Aunt Carrie's Poems*.

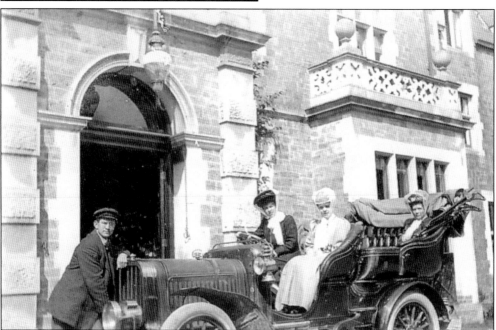

William Markley joined the Post family on the 1907 trip to England. Maybe he was looking out for the ladies while C.W. Post conducted some business. Markley is standing in front of the automobile, and the ladies appear to be, from left to right, Marjorie, Leila, and Mollie. (Courtesy Bill Forrester.)

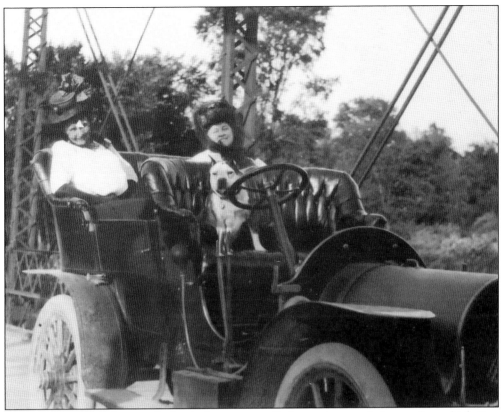

This automobile, with its tucked upholstery, was called a touring car. It is not clear which Post woman is which, but the American bulldog is in charge. Although the dog is also unidentified, he gets to go everywhere wearing his spiked collar. Below, he appears again riding along with C.W. Post. This must be the norm, for the horse doesn't seem to mind. Both images are from around 1908. (Both, courtesy Bentley Historical Library.)

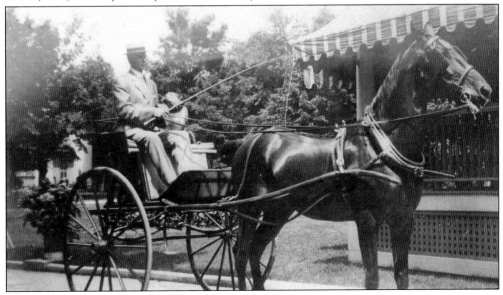

In 1905, C.W. Post said, "A large industry reminds me of a big clock. The face is like the factory grounds, the workmen move about like the hands, and are seen most, the foremen, bookkeepers, cashiers, timekeeper, superintendent and heads of departments are the wheels, and away back there somewhere is the boss, the mainspring that must be strong and kept wound up to keep the wheels and hands going; but every piece is important, and each must do its part, and do it faithfully."

Two
A Town For the People

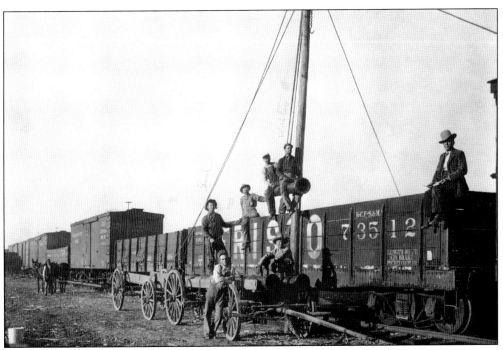

This 1907 photograph was taken at the railhead of the Texas & Pacific Railroad in Big Spring, where supplies were shipped in for the building of the new town. C.W. Post had ordered 72 of Missouri's finest mules and 24 sturdy new wagons to haul the freight. It took three days for the experienced mule skinners to load the wagons and another four days travel across 70 miles of rough country to the town site of Post. (Courtesy Bentley Historical Library.)

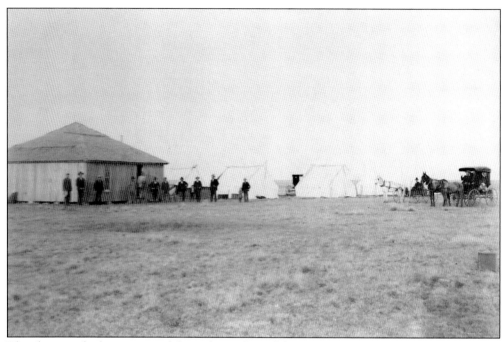

The photograph above is one of the earliest taken of the new townsite of Post City in 1907. The building at left is the commissary, and the tents were housing for the workers. Post can be seen in the buggy at right. The other gentlemen are unidentified but are probably employees of the Double U Company. Soon, it was discovered that the selected townsite was not in the center of the county, so all work ceased and relocated to just below the caprock escarpment. The building began as reflected in the photograph below as stonemasons Scotty Samson and Jimmy Napier had crews hauling in the stones by the wagonload, and wagons of lumber and supplies were brought from the railhead in Big Spring. A flurry of activity was occurring as workmen began building C.W. Post's town for the people.

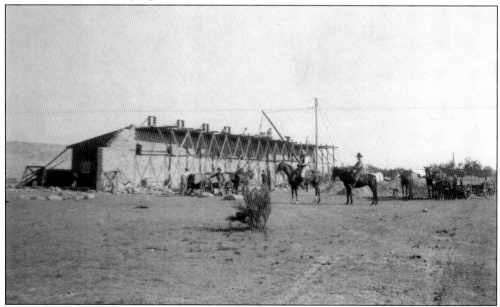

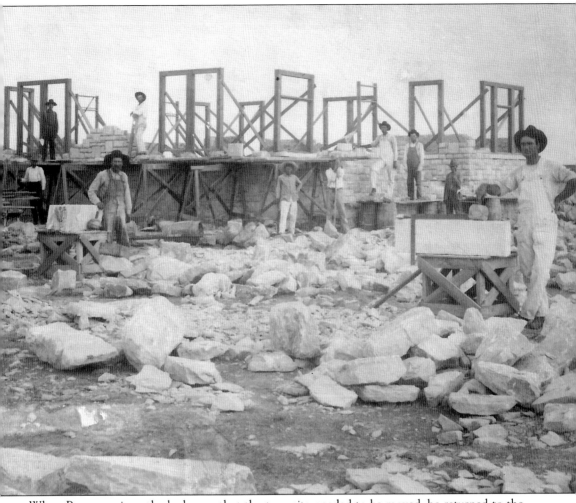

When Post was given the bad news that the townsite needed to be moved, he returned to the area on May 19, 1907, to choose a new site in the breaks just below the rim of the caprock. Once again the building commenced. Post got everybody lined out and sailed to England on June 19, 1907. As crews began blasting out a road down the caprock, a deposit of white sandstone was discovered, ideal for building the new town. Big slabs of stone were loaded onto wagons of four-mule and four-horse teams and brought to the building site. This 1907 photograph shows the men working with the stone. The two stonemasons are Jimmy Napier at the left bench and Scotty Samson on the right. The men in the background are unidentified. Samson and Napier were working in Georgetown when they heard about a new town under construction. A telegram of inquiry was sent to Post, to which he replied, "Come now, C.W. Post." Scotty was only 21 years old when Post made him a foreman.

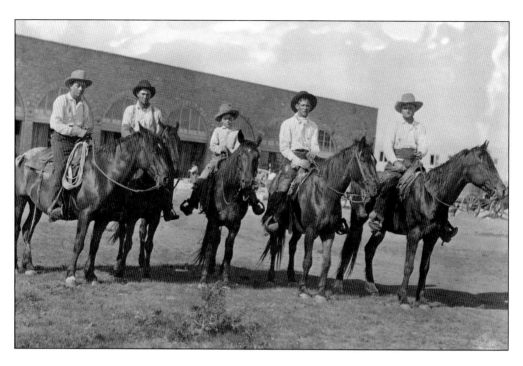

Post cowboys in this 1907 photograph are, from left to right, Jake Neff, Jim Wilks, Ira Lee Duckworth, Bud Duckworth, and George Duckworth. The building behind them is the Double U Company building. C.W. Post described it as the first building constructed with stone from the quarry on his land. It is 160 feet square, and as soon as it was finished, he filled it with groceries, hardware, hats, shoes, paints and oils, and carloads of wagons and farm machinery and implements. Below is Uncle Tom Stevens sitting on the porch of C.W. Post's first house in Post. Standing is William Markley. The stones visible in the house show the craftsmanship of the stonemasons, who worked one stone at a time with primitive tools. With unbelievable precision and stamina, they were able to endure extreme hard labor. (Both, courtesy Bentley Historical Library.)

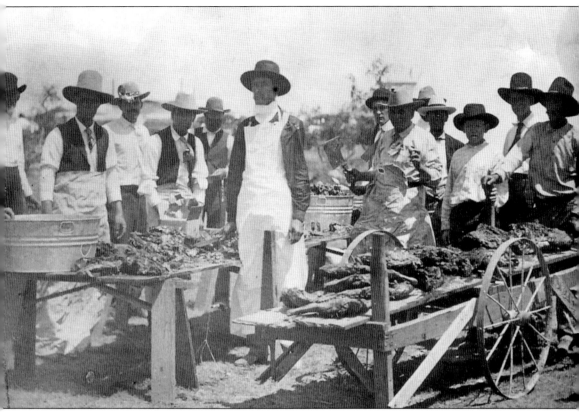

W.E. Alexander, general manager of the Double U Company, is seen in the center of this 1907 photograph wearing a white apron and bandana. The occasion is a Fourth of July celebration. Old-timers in the new town challenged Alexander to throw a big barbeque with an open invite for everyone to attend. They said they would furnish the meat if he would provide the bread and pickles. J.F. Hartford, manager of the farms, is the man holding the meat cleaver. Looking over his shoulder, wearing a straw hat and bow tie fourth from right, is John Slaughter, who the year before sold C.W. Post 50,000 acres of land on the High Plains for $225,000 cash. The second man from the left is Uncle Tom Stevens. All others are unidentified. On July 8, county elections were held, and Post City was officially declared the county seat of Garza County. (Courtesy Bentley Historical Library.)

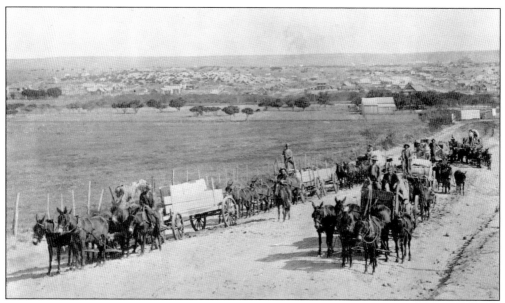

One correspondent who came to Post City with the Post family noted that they were awakened at dawn by the sound of bells. At first, it was far away, then it came nearer down the trail until at last it passed by and then stopped. It was the arrival of the wagon train from Big Spring. It was quite an event. The train consisted of 17 wagons, each drawn by six mules, and a chuck wagon pulling up the rear from which the cook served meals to the boss and the other drivers. That night, lots of commotion could be heard coming from the corral, and soon the wagon train was ready for the 80-mile return trip to Big Spring. Below is Sam Wilks, the wagon train boss (sometimes called a mule skinner). Uncle Sam was a pioneer rancher. This photograph was found in the Post family private papers at Ann Arbor, Michigan. (Below, courtesy Bentley Historical Library.)

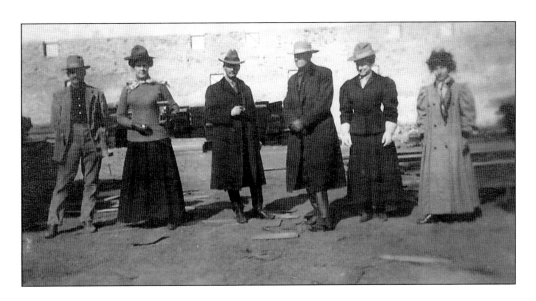

The photograph above was taken in the early stages of building the town. Standing from left to right are William Markley, Leila Post, Ed Close, C.W. Post, Marjorie Post Close, and Lucile Stevens. A reporter from Battle Creek described the scene as the Post party arrived at Post City: "It was a late afternoon in November when our party came to the edge of the mesquite valley—the rim of the Caprock—site of the new city of the plains, and before we started down trail, Mr. Post halted the automobiles so we might get our first glimpse from that vantage ground. There it lay in various stages of construction. Stillness of the area was broken by the sounds of industry, the ring of the carpenters' hammers and the blasting of the rock high up in the buttes beyond." Below is the first Garza County Courthouse under construction.

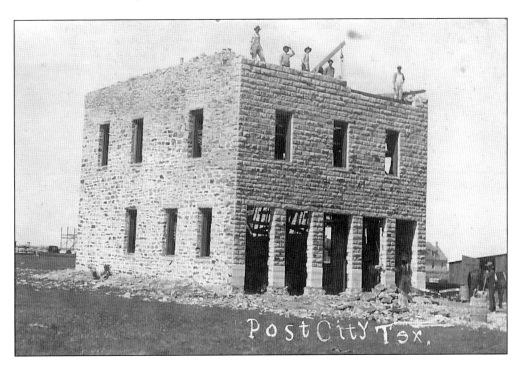

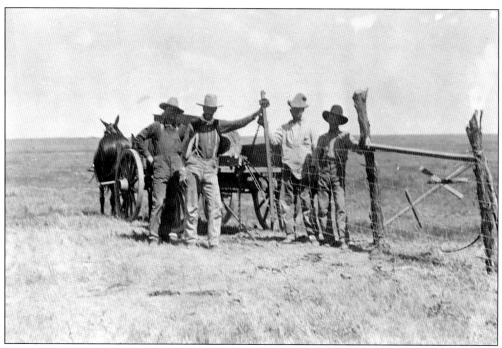

This Double U fencing gang is installing "rabbit-proof" fence wire on the Post experimental farm in March 1907. Those rabbits must be mighty big, as this looks more like hog wire. Bud Duckworth is on the far left; the others are unidentified. (Courtesy Bentley Historical Library.)

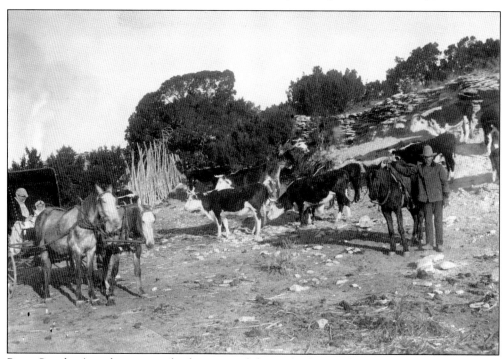

Perry Crowley (standing next to his horse at right) was the first mail carrier for Post City in 1907. Mrs. Crowley and the baby are in the carriage at left. (Courtesy Bentley Historical Library.)

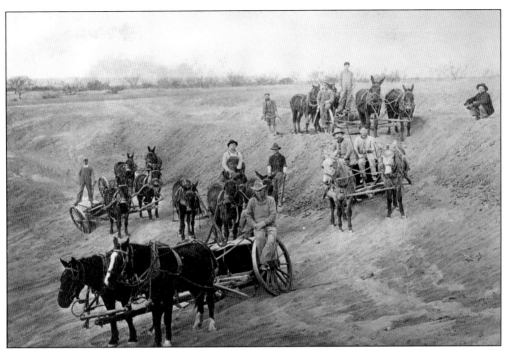

These Double U mule- and horse-drawn fresnoes are excavating an area for the first reservoir for the waterworks needed for the new town in 1907. (Courtesy Bentley Historical Library.)

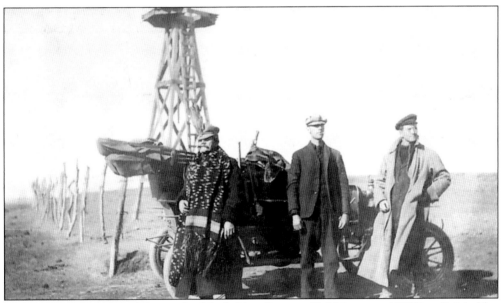

In this 1907 image, from left to right, Uncle Tom Stevens, H. Holmes, and William B. Markley seem to be surveying something. Stevens played a huge role in the locating and purchasing of the C.W. Post lands in Post, Lynn, Hockley, and Garza County. They apparently maintained a brotherly relationship that lasted for a lifetime. (Courtesy Bill Forrester.)

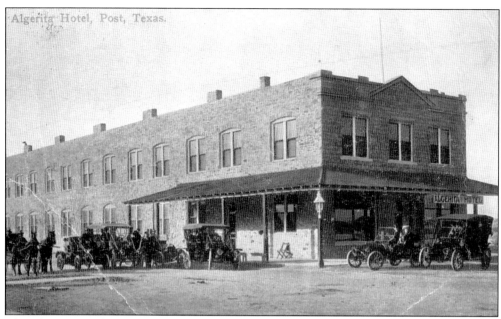

The Algerita Hotel, owned by Post, opened for business on July 17, 1908, as seen in the above photograph, with 30 rooms with modern improvements, bathrooms, and water-flushed water closets. The charge per day for the workmen's accommodation was $1, $2 for the best room in the house. When the hotel consistently failed to clear its expenses, rates were raised to $2.50 per day. For those guests who complained the rates were too high, Post had a card made and placed behind the desk that contained this message: "THE RATE OF THIS HOTEL IS $2.50 A DAY. THERE ARE PLENTY OF GOOD BOARDING HOUSES IN TOWN AND PLENTY OF ROOM IN THE MESQUITE. FOURFLUSHERS, KICKERS, AND OTHER SUSPICIOUS CHARACTERS FIND BOARD WITH THE SHERIFF. WHEN IN DOUBT, HIT THE MESQUITE." Below, L.M. Brown seems to be ready for the dinner crowd in 1908. (Below, ourtesy Bentley Historical Library.)

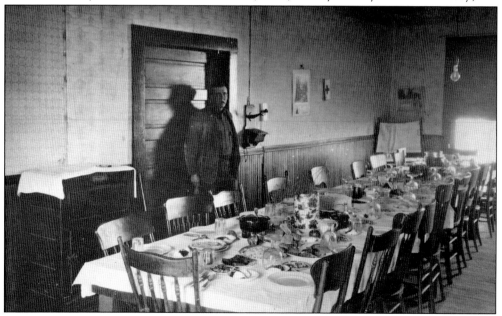

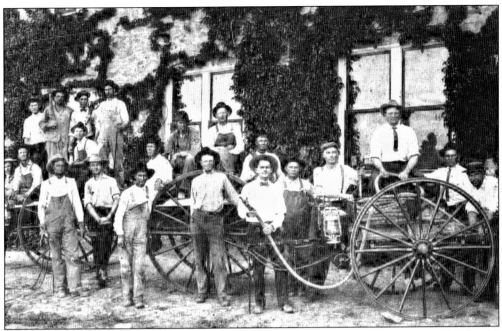

This early picture of the first Post Volunteer Fire Department shows the first fire chief, W.T. Mann, in the center holding the fire hose. One of the Duckworth boys appears to be holding the other end. Their fire wagon and equipment look very primitive compared to today's standard, but they were forever being put to the test. Most of the men look like the Double U crew. (Courtesy Bentley Historical Library.)

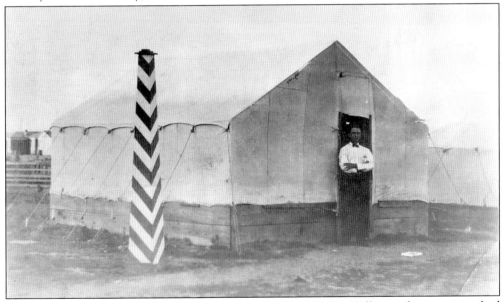

The first barbershop in Post City was set up in a tent in 1907. Jim Williams, the proprietor, had been operating a barbershop since the town was built. He often cut C.W. Post's hair and said it was not difficult because he had so little to cut, being that he was very bald. Williams said Post was a great storyteller and was especially fond of hardworking men in overalls and the common man in general. (Courtesy Bentley Historical Library.)

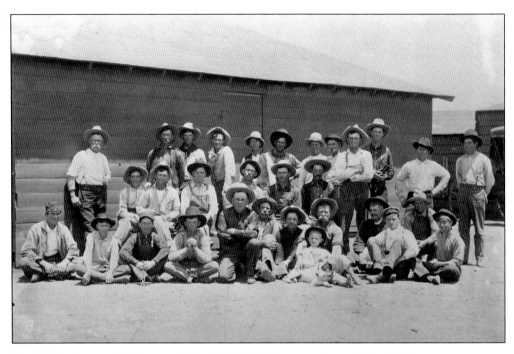

The 1907 photograph above is of the Double U Company boys, although their names are not listed. Two or three Duckworths are seen in there (including Ira Lee, the young lad on the front row with his dog). The Double U Company was formed to run the operation and building of the future colony. The charter was incorporated on March 23, 1907, with a capital stock of $50,000, and the corporation was to be called the Double U Company. Below, the early photograph features, from left to right, H.C. Hawk, Post's personal secretary and right-hand man; M.M. Knisley; P.A. Swarts, in charge of office work and board secretary of Double U; and J.F. Hartford, all of whom are enjoying a great cup of "cowboy coffee." (Above, courtesy Bentley Historical Library; below, courtesy Bill Forrester.)

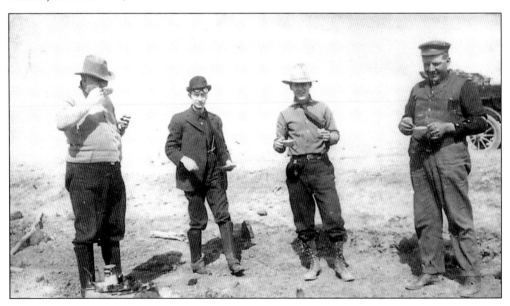

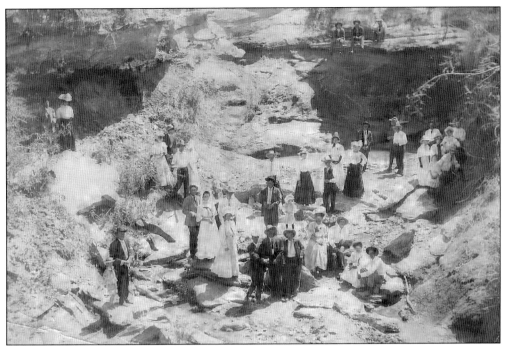

Here, the townsfolk gather at the caprock for a picnic social. They are all dressed up in their finest, and according to the way they are dressed, it must have been in the springtime. In Garza County, a person can pretty much count on one or more big fat rattlesnakes lying on those warm rocks. Maybe the guys checked for snakes before the ladies arrived—or maybe not.

W.T. Mann was the first postmaster for Post City and the first fire chief with the Post City Volunteer Fire Department. Here can be seen some of the beautiful landscapes in Garza County. (Courtesy Bentley Historical Library.)

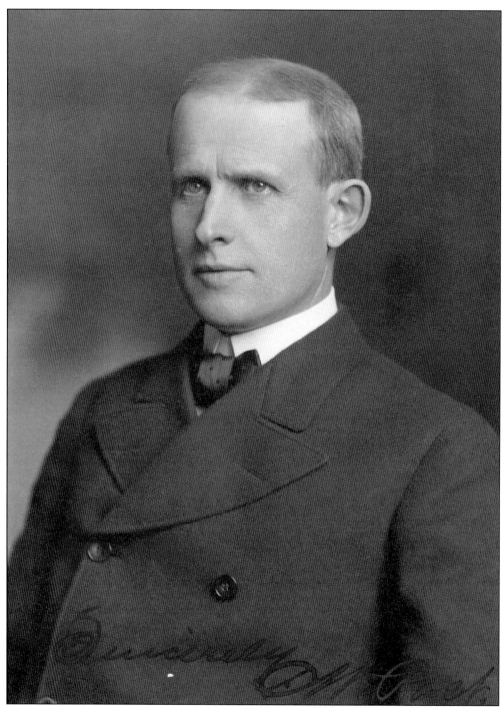

C.W. Post said, "My type of the sturdy, just and dependable citizen is the man who works with his hand and brain combined. Such men work in factories and have perhaps a home paid for, or money saved and invested where it earns them something. Such men work on farms they own and put their surplus earnings where it works for them. Such men can also be found at the head of factories, farms and ranches."

Three
STROLLIN' DOWN MAIN STREET

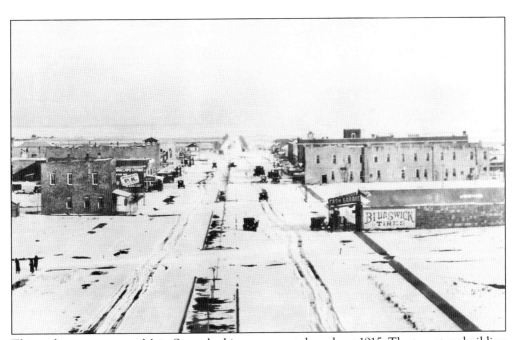

This early snow scene on Main Street looking east was taken about 1915. The two-story building on the left is the first Garza County Courthouse. Note the Brunswick Tires sign on the garage. Solid rubber tires came on the market in 1909. The next large stone building is the Algerita Hotel, built in 1908. Next door to the Algerita is the large brick Double U Company office building, built in 1911.

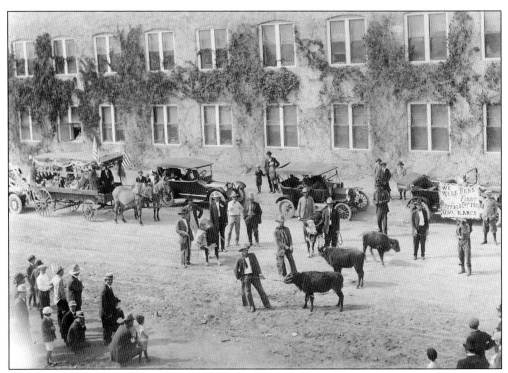

The sign held by the gentleman at right reads: "We were here first—buffalo from the U Lazy S Ranch." The ranch owner was John B. Slaughter. This was Slaughter's 1919 parade entry at the Garza County Fair parade lined up next to the Algerita Hotel. The fellow standing to the right of the sign dressed in knickers and cap appears to be young Jay Slaughter. The automobile behind him looks remarkably like the one he was driving when he had a big wreck, flipping upside down.

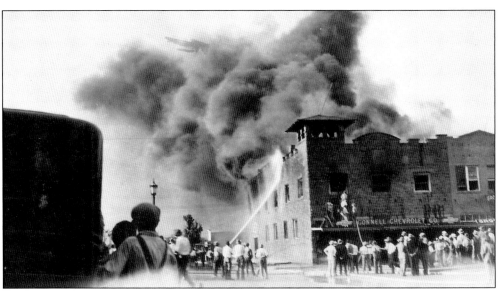

One of the worst fires in Post City was at the Connell Chevrolet Company around 1930. It was engulfed in flames that totally destroyed the upper floor. The building still stands today—just minus its second floor and tower.

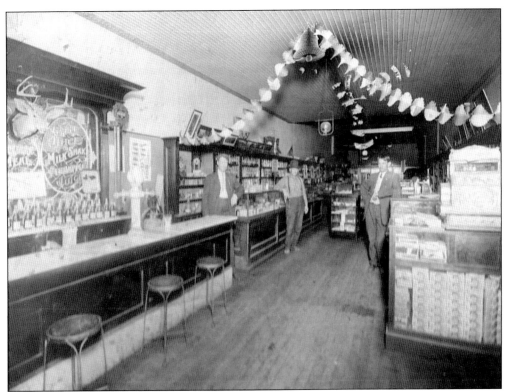

The above photograph was taken on July 4, 1909, at the R.L. "Dock" Collier Drug Store. The store was located in the Double U building on East Main Street. Collier and associates purchased the drug rights in Post from C.W. Post in 1907 for $2,000, with the stipulation that no whiskey would be sold. R.L.'s son Bob Collier returned to Post in 1948 to open his own store—Bob Collier Drug—to continue the family tradition. In the photograph below, the three men at the end of the table are, from left to right, Bob Collier; his father, "Dock;" and his brother Wynne at the grand opening in 1948. The gentleman at far right may be Deacon Dalby. Bob Collier is a rare gentleman, greatly admired by all in Post. He wrote a delightful book in 2007 called *The Blooming Drug Store* and is a loyal Rotarian. (Both, courtesy Don Collier.)

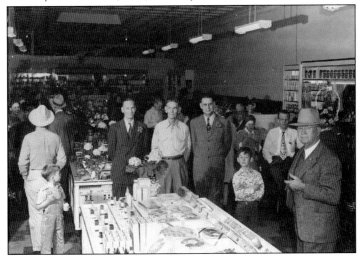

The Jim Power Grocery and Market, as shown in the undated photograph above, was a prominent business in Post until 1948 and dating back to the beginning of the town. His father, James Power, was the first grocer in the county. Below is an early photograph of Graeber's Grocery Store, located in the old Algerita Hotel building—it was also known as the Red and White Affiliate. W.R. Graeber is the gentleman on the left wearing an apron. The others are unidentified. Those were the days when a man's word meant something—he selected his purchase, signed a ticket, and paid later at the appropriate time. If mom sent her children to the store, they could select a piece of candy or a soda to enjoy on the walk home, with permission of course; otherwise, the clerk might refuse.

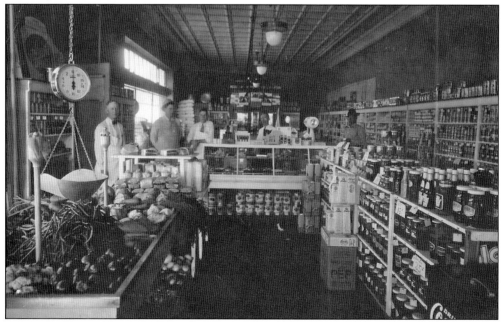

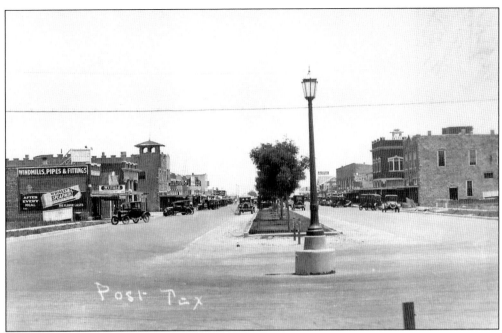

This c. 1920 photograph shows many automobiles parked at various businesses in downtown Post City. This scene is of Main Street looking east. Note the mural on the building on the left. The Wrigley's Spearmint package looks almost exactly the same today. Later the Tower building would be missing its tower and second floor due to a fire. Today, the center median is also landscaped with trees and grass.

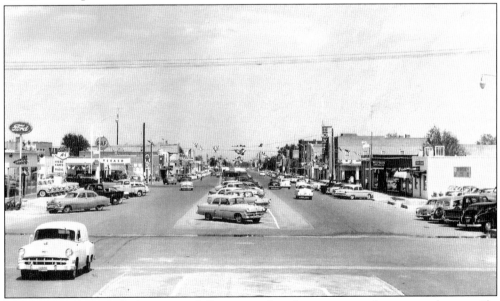

The 1950s were so cool; there was a different mood in the country, and cars were the rage. If a person did not have a nice automobile, then one was probably on order. When new car models were unveiled in the fall, it resembled a movie premiere—the cars were the stars. Spotlights were waving back and forth lighting up the sky, luring the public to the dealership. And so it was in Post City with automobiles lining the streets.

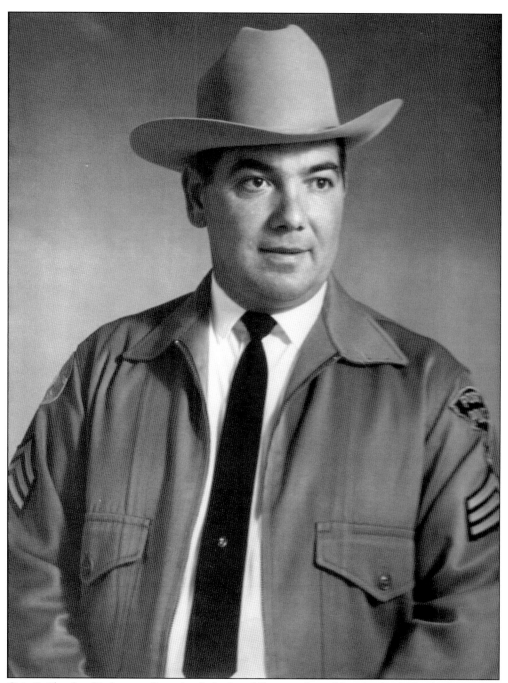

Otis G. Shepherd Jr. became Post chief of police following the sudden death of Chief Bill Gordon. Shepherd came to the position with 14 years' experience serving as police sergeant under Gordon, and he had been a member of the city police department since it was established in 1957. He served as city marshal prior to that time. Junior, as he was known by all, served until 1974.

Post City was founded in 1907 and governed by Garza County officials until the population reached 1,000. It was 1916 when the town became a municipality, appointing W.L. Davis (right) as Post's first mayor to hold the office temporarily from March 14 until May 2, 1916. Following the election, a new mayor, T.R. Greenfield, took office, serving from 1916 to 1924. To date, the city has had only 20 mayors, with Giles C. McCrary holding office the longest—22 years, from 1969 to 1991. Only two have been females, Kim Mill (2007–2009) and Thressa Palmer Harp (below), who took office in 2009 and was reelected to a second term.

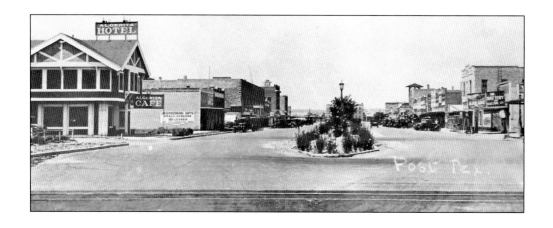

The above photograph provides a great view looking east all the way to the courthouse—note the Garza Theater once had the name Palace. The second Algerita Hotel is seen on the left. Once the train came in 1910–1911, a new hotel was built to be more convenient for the passengers. Below is a close-up of the Algerita. Both photographs are from around 1920.

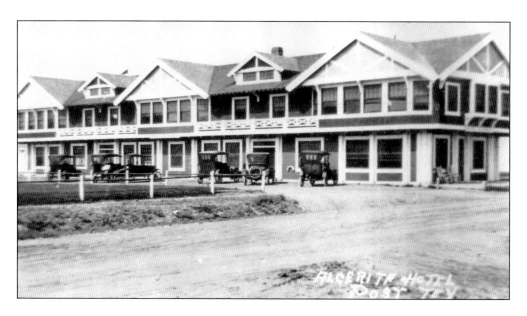

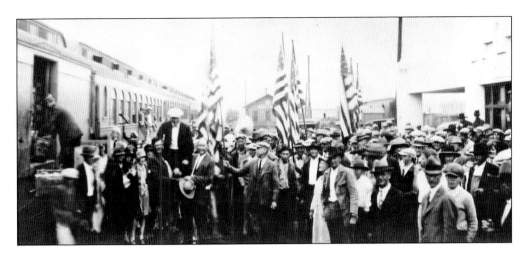

Here is George (Scotty) Samson returning from the Dallas Fair after winning first place for his Garza County Exhibit in 1926. Everyone one is all dressed up and excited to welcome the Scotsman home. Scotty is the one sitting on someone's shoulder. Post no longer has passenger trains—or any trains, for that matter—stopping in town. The old Santa Fe Depot has a new face-lift and purpose, as it is now used by the Post Area Chamber of Commerce. In Post City, there is usually something going on downtown, and the occasion shown below appears to be a drawing just in time for the 1962 Christmas season. Note the huge Christmas tree erected in the median. Looking north provides a great shot of the old First National Bank building. A band is even present.

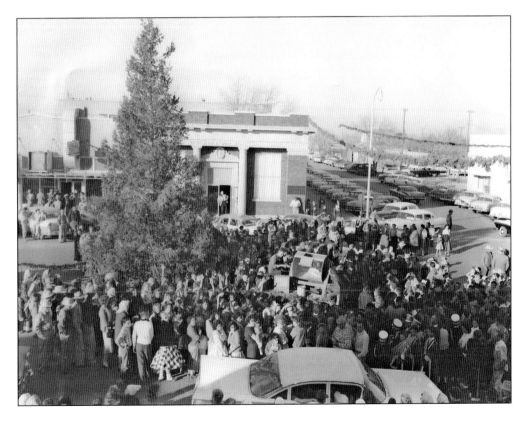

In 1902, Post said, "Fairy stories told about successful men sometimes lead others into investments that are ruinous to them. It seems to be better that the truth be known in order that men can have some tangible basis upon which to form their conclusion."

Four

LIFE BELOW THE CAP

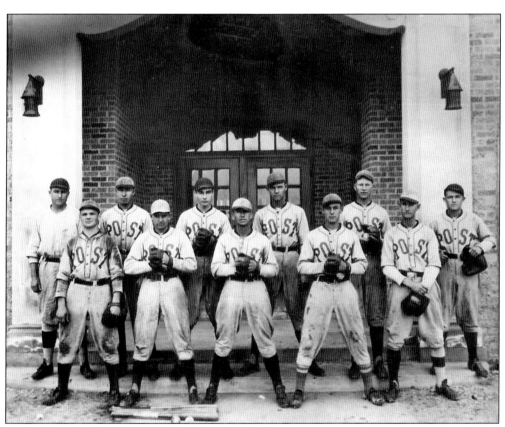

Here is the Post baseball team of 1928. From left to right are (first row) Zizzy Williams, Alex Chaney, Pud Luman, Dude Williams, and Charles Cravy; (second row) coach Harry Taylor, Claborn Pirtle, J.D. McCampbell, Bill Aubrey, Cecil Cearley, and Frentz Pierce. It looks like Zizzy's been sliding into home.

F.P. Moss was superintendent of Post schools in the early 1900s. He lived in the James Durrett home. He was a bachelor who never married. He played the piano beautifully and was a graduate of Kidd Key College and held a second degree from California. His hometown was Waxahachie, Texas.

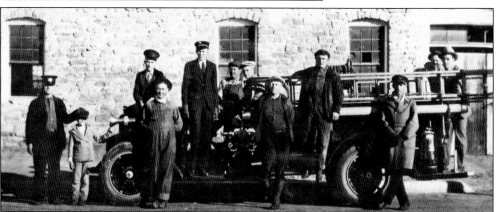

The early-day Post Fire Department, possibly pictured in the 1920s, is shown to have at least 11 firemen and a young lad. Their names are, from left to right, John Fumagalli, unidentified, Frank Stevens, Bob Lee, Jim Hays, Fatty Lowe, Shirley Robbins, Ernest Fumagalli, Dick Woods, Jim Hundley, Floyd Stanley, and Jew Moses.

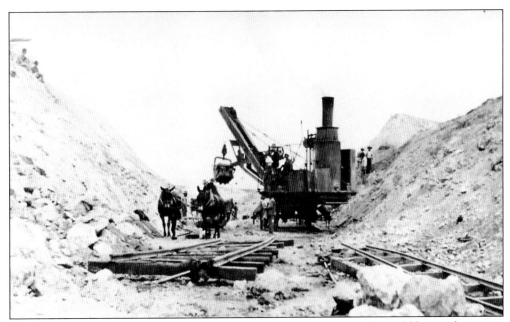

Steam engines were used to cut through the caprock so the train tracks could be put down into Post City. The year was 1910. Tracks finally reached Post in 1911, with the first train backing down the cap to the new Santa Fe Depot.

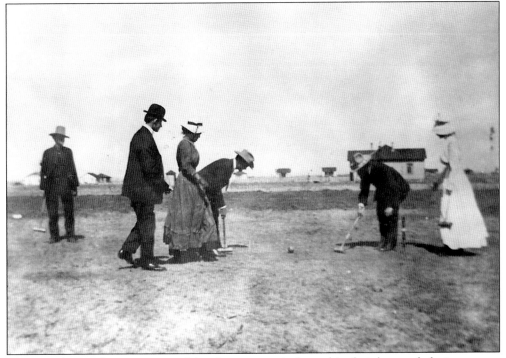

This must be Sunday go-to-meetin' day, for everyone is dressed in their best and playing a game of croquet, which use to be a very popular game for everyone, especially at social events. That was before professional sports became the rage. Looking in the background, there are just a few homes built, an indication that this photograph was probably was taken around 1908.

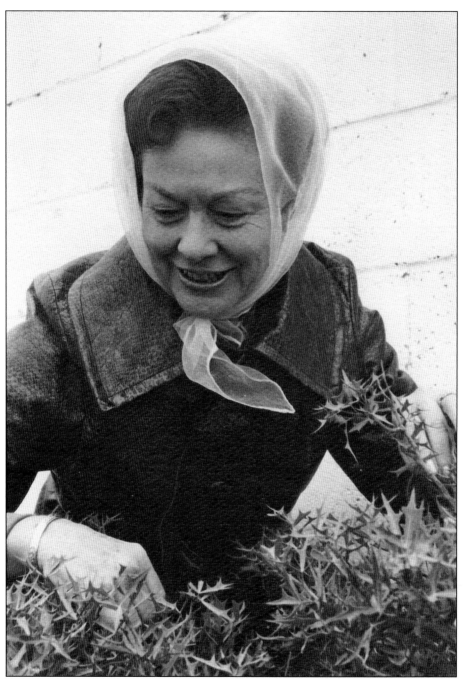

Maxine Durrett Earl was one of the most civic-minded ladies of the town. Here she is seen in January 1974 planting flowers and native bushes at the Algerita Park, a project sponsored by the Post Chamber of Commerce and E.A. Howards and his FFA class. The Algerita Hotel and Algerita Park are both named after the prickly bush that Maxine is handling. Note the headscarf—it was once a necessity for women's apparel. Maxine was a schoolteacher for many years, a merchant (she was the owner of Maxine's), and on the Post City Council. She always had a great love for the city of Post. Her father, James Durrett, worked as a bookkeeper for C.W. Post.

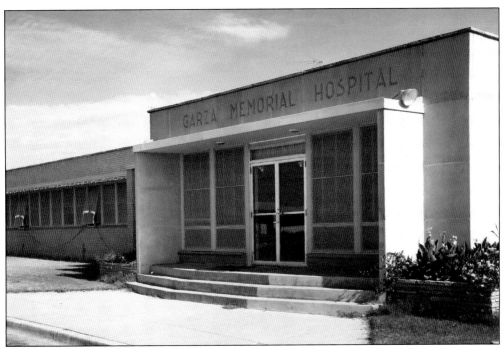

The Garza Memorial Hospital was built in 1952, as seen above, and admitted the first patient on August 4 of that year. Melba Cowger Eitniear, RN, was the second nurse hired. In 1957, Post celebrated its 50th anniversary, and hospital staff was asked to dress in early-20th-century costumes. Staff member Hallie Caylor volunteered to make the costume/uniforms to be worn during the festivities. If the sheriff caught those who were to be in costume not properly dressed, they would be arrested and put in jail on the courthouse lawn until someone bailed them out. The hospital also celebrated its fifth anniversary with an open house. Nurses from left to right are Joy Barron, Hallie Caylor, head nurse Melba Cowger, Sylvia Shaw, and Sephina Martinez. (Courtesy Melba Cowger Eitniear.)

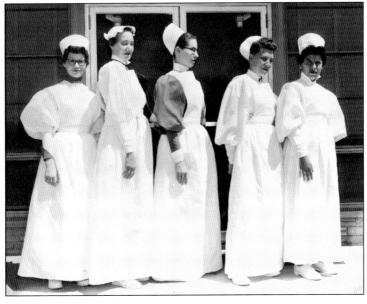

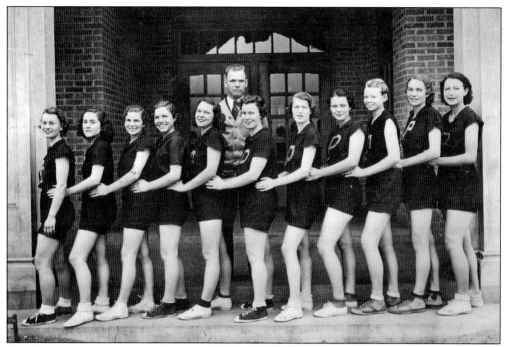

The Post Lady Lopes basketball team of 1934–1935 looks to be ready to meet their competition. Coach Jess Cearley stands behind the team (from left to right), Consuela Baker, Lois Howell, Mary Redman, Eva Teaff, Dorothy Harrison, Mary Baker, Dorothy Crisp, Erma Satterwhite, Eula Mason, Pauline Willis, and Faye Richardson. O'Neta McFadden was not present for the photograph. Cheerleaders were Ira Duckworth and Consuela Baker. (Courtesy Young family.)

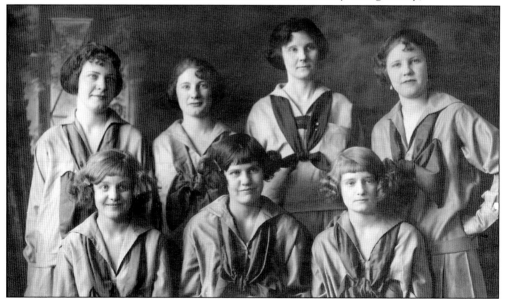

This early Post ladies' basketball team appears to be from the 1920s. The young ladies have sharp-looking uniforms, and look at those hairdos. From left to right are (first row) Carmen Thomas, Minnie Furr, and Lula Jo Brandon; (second row) Bell Kemp, Panzy Floyd, Miss Page, and Neva Kemp.

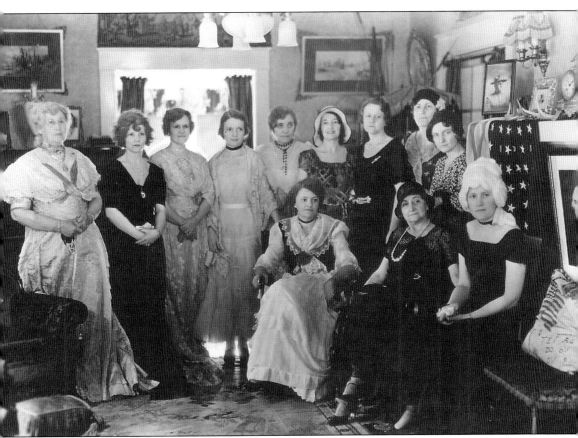

Mrs. John B. Slaughter hosts a costume party for the Women's Culture Club in 1927. The membership was always held to just 12 ladies, no more, with each member committed to host the club for one monthly meeting through the year. The married women of the day apparently did not mind that they had no first names, for the norm was to be tagged "Mrs. Whomever." Since these ladies are all prominent and active community leaders, it must just be proper. From left to right are Mrs. John B. Slaughter (Belle), Mrs. Jay Slaughter (Skeeter), Mrs. C.D. Morrel (Johnny), unidentified, Mrs. Tillman Jones (Maggie Mae), Mrs. John Herd (Eloise), Mrs. Giles Connell (Gussie), unidentified, and Mrs. Walter Duckworth (Covey). Seated are, from left to right, Mrs. Ollie Weakley (Kate), Mrs. Cap Roy (Myrtle), and Mrs. D.C. Williams (Lois). This occasion would appear to be Washington's birthday.

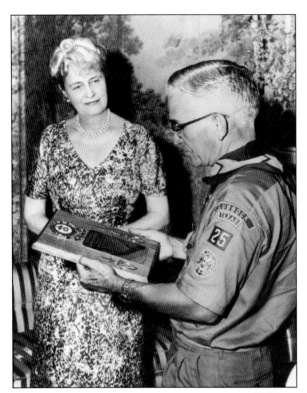

Marjorie Merriweather Post is being honored on July 9, 1957, by the Boy Scouts of America for her generous donation of the C.W. Post Memorial Scout Camp near Post. The presenter is John W. Thomas, executive board member of the South Plains Council of the Boy Scouts of America, from Ralls, Texas. The text on the plaque is a real tribute to the Post family. (Both, courtesy Bentley Historical Library.)

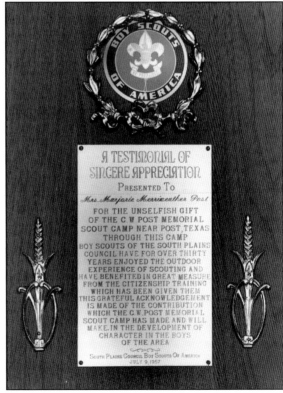

W.R. Graeber and wife Minnie are standing in the yard of their home, built in 1911, in the photograph at right. The structure originally served as the dormitory for the nursing school located at the Post Sanitarium next door. Today the building is the Heritage House, owned and operated by the Caprock Cultural Association. The Graebers were grocers in Post for many years. Below around 1920 are the Presson ladies (from left to right), Minnie Presson Graeber; Gladys Presson, a fine artist and art teacher; and Nellie Presson.

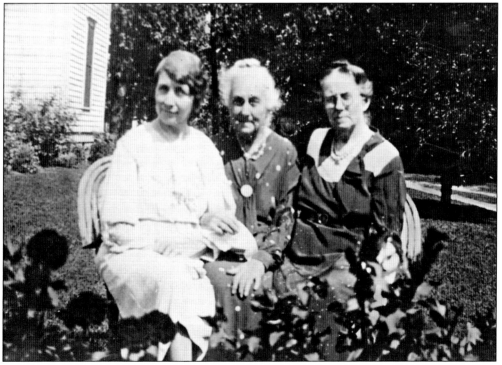

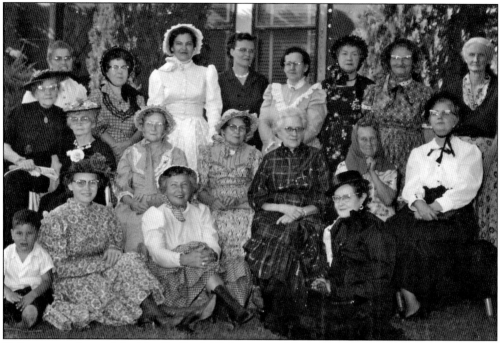

Eighteen members of the Needle Craft Club are posed here: Mrs. Schmidt, Mrs. Malouf, Mrs. Dietrich, Mrs. T.A. Gilley, Mrs. Boone Evans, Mrs. Scott Storie, Mrs. Lee Bowen, Mrs. Tanner, Mrs. Smith, Mrs. J.M. Boren, Mrs. T.L. Jones, Mrs. W.L. Porterfield, Mrs. J.R.Durrett, and five unidentified ladies, along with a young man. The date or occasion is unknown, but it probably was 1957, during the 50th Jubilee. It appears the Needle Craft Club members have each sewn their vintage costumes and are sporting lovely hats. The 1957 photograph of the parade below is part of that celebration. (Below, courtesy Bill Aten.)

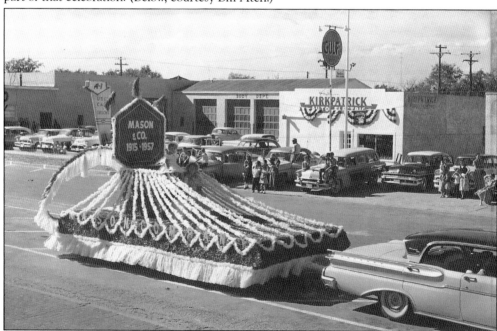

Jay and Skeeter Slaughter always seem to have great fun together. Here they are at Atlantic City attending the 1936 Rotary Conference. Only wealthy Texans, who are Rotarians by the way, could get away with strutting down a busy street wearing ten-gallon hats, boots and spurs with their brands tooled on them, and each packing six-shooters. (Both, courtesy Slaughter family.)

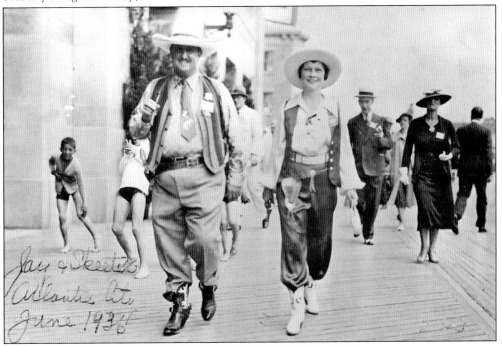

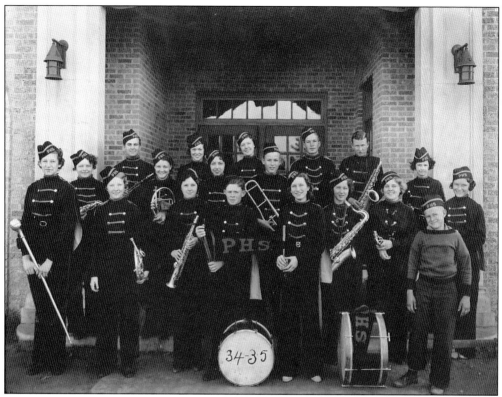

This Post High School band of 1934–1935 is, from left to right, (first row) unidentified, ? Norman, unidentified, ? Woods, three unidentified, and E.J. Robinson; (second row) ? Adamson, unidentified, Virginia Sims, and three unidentified; (third row) Burt Anderson, Maxine Durrett, Rosemary Surman, unidentified, and James Deitrick.

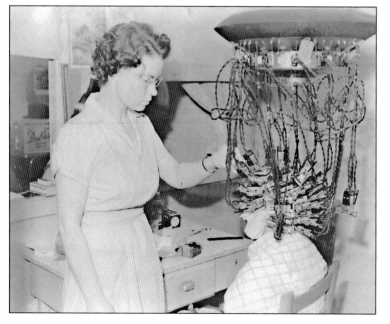

Here stands Mary Gale Young in her beauty shop around 1937 as she puts the finishing touches on an unidentified customer, hooking her up to a very scary-looking perm machine. Mary Gale looks very calm, but the person connected to those wires may be a little anxious or maybe has fainted already. Now in her mid-90s, Young is no longer doing hair but still has that bubbly personality.

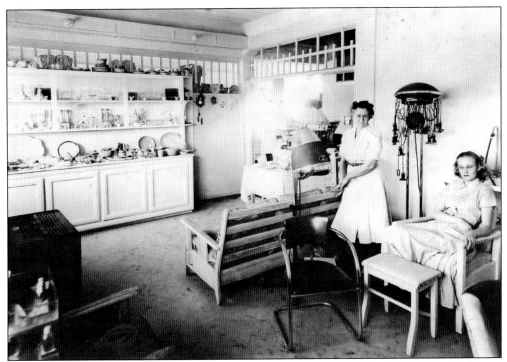

Nora Stevens's dress shop and beauty parlor was located across from the Garza County Courthouse. Ladies in the photograph below are, from left to right, Gladys Hyde, unidentified, and Nora Stevens. Above, Nora Stevens is standing and Gladys Hyde is seated. This shop also had one of those electrical perm machines, which was apparently common for that era. Both images are from around 1940.

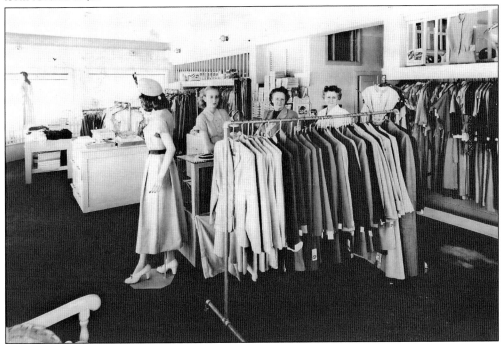

The Algerita Hotel was the first hotel built in Post in 1908, and it later housed various businesses—a bank, a grocery store, and a senior citizens center to mention just a few. In 1983, the Post Art Guild, Inc., doing business as the Algerita Art Center, turned the front half of the building into two working galleries that were in business there for about 28 years. In the photograph below are Post Art Guild members and associates posing for the ribbon-cutting for the "new" Algerita Art Center. From left to right are (first row) Vicki Diggs, Lil Conner, Pres. JoAnn Mock, Sheri Riedel, Mayor Giles McCrary, and Lewis Earl; (second row) Linda Puckett, Marie Neff, Bryan Williams, Geraldine Butler, Ruby Kirkpatrick, Quinnie Cook, Thelma Bilberry, Inez Hartel, and David Newby; (third row) Les Seals, Ann Bratcher, Sara Ault, Nancy Childers, Glenda Morrow, Polly Cravy, and Maxine Earl.

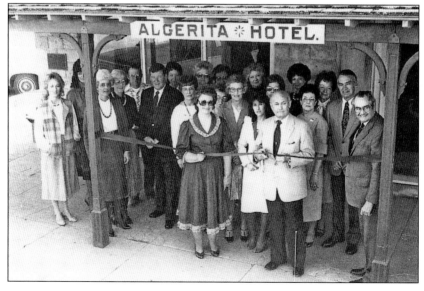

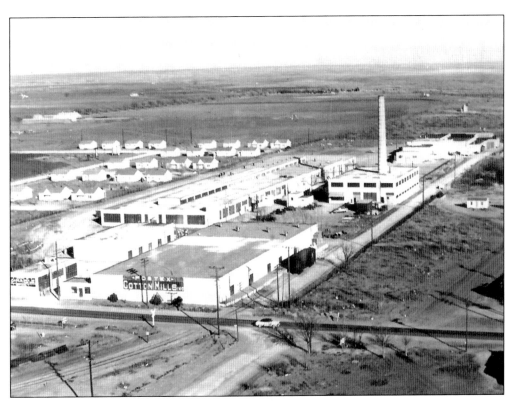

The Postex Cotton Mill was built by C.W. Post in 1913 at a cost of $650,000. It may have been the first of its kind in the nation or possibly the world. His goal was to bring locally grown cotton from the field to the mill and manufacture sheets and pillowcases under the names Garza and Postex, providing jobs for the people of his new town and an economic base that would sustain the area for decades. Mill houses were available for some employees. At right, Susan Pennell is seen tending the spools of thread.

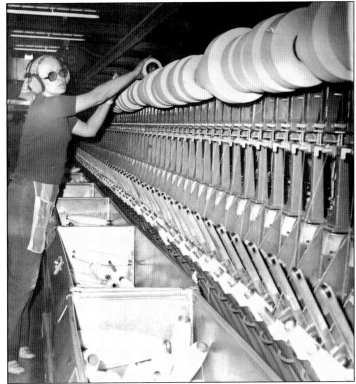

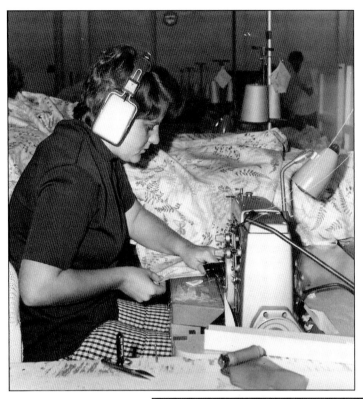

At left, Ila Workman is steadily busy hemming a sheet, and the noise must be quite loud, as she is wearing a headset for safety measures. Note the printed sheet, probably produced in the 1970s. Below is Jane Redman, also in the sewing room, probably sewing pillowcases.

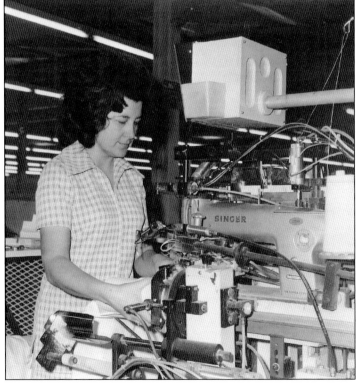

Zoe Merriman, crowned Miss Lubbock of 1953, poses at left for a publicity shot for the Miss Texas contest to be held in Galveston in July 1953. Zoe was 18 years of age at the time and a sophomore at Texas Tech University. Below, she is seen wearing her evening gown at the Miss Texas contest. The pageant was sponsored by the Galveston Junior Chamber of Commerce with 18 of the most beautiful and talented girls competing for the crown of Miss Texas. While Zoe wasn't selected to wear the crown, she was honored to have served as Miss Lubbock for 1953.

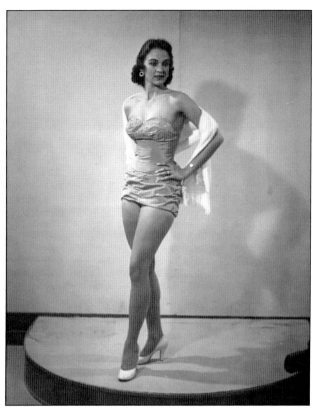

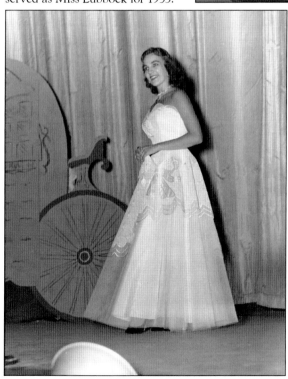

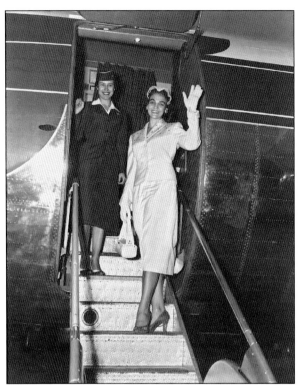

Miss Lubbock Zoe Merriman goes to Galveston. Seen at left in a 1953 photograph, Zoe is boarding a plane for Galveston to compete in the 1953 Miss Texas contest to be held July 24–26. Airline hostess Peggy Shepherd welcomes her on board. Her mother, Elsie Merriman, accompanied her on the trip, with her father and a group of Lubbock Jaycees at the airport as she departed. She lettered on the women's fencing team for Tech and in recent years was honored as a member the Double T Association. She is an author and award-winning actor in local live theater productions and was selected Citizen of the Year in 2004. Zoe married Jack Kirkpatrick in June 1954 and graduated from Texas Tech 1956. Below from left to right are Elsie Merriman, Zoe's mother; Zoe Merriman; and soon-to-be mother-in-law Ruby Kirkpatrick.

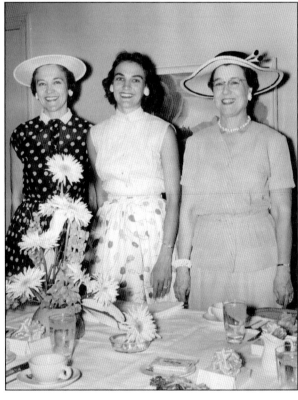

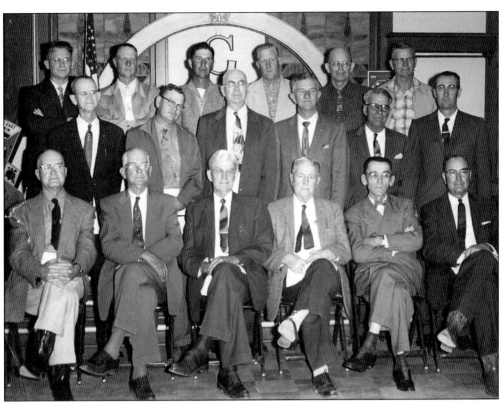

The date of this photograph is unknown. It was taken at a gathering of Past Masters' Night at the Post Masonic Lodge with a number of past masters in attendance. From left to right are (first row) Walter Duckworth, O.L. Weakley, Dr. A.C. Surman, Bob Warren, Ira L. Duckworth, and Phil Bouchier; (second row) Dean Robinson, C.R. Thaxton, J.A. Stallings, Bailey Matsler, Lester Nichols, and Paul Jones; (third row) R.B. Dodson, Wilburn Morris, Walton McQuien, Luther Bilberry, A.T. Nixon, and E.E. Pierce.

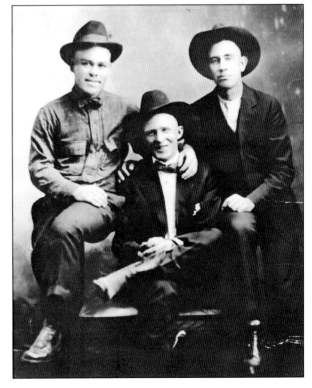

Garza County's first three men to enter the Army in 1917 are, from left to right, Walter Duckworth, John (Red) Rogers, and ? Waters. All three look like they are big buddies and probably talked each other into enlisting.

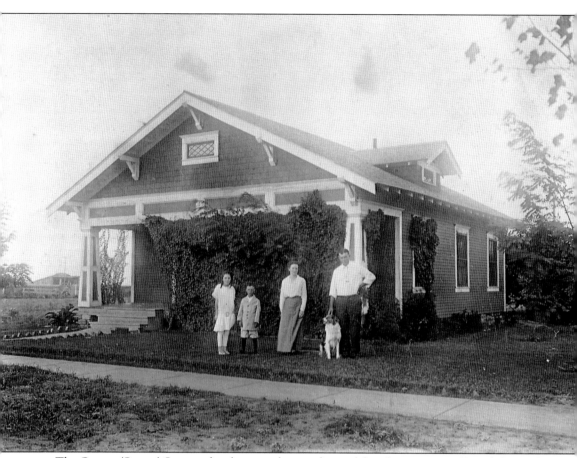

The George (Scotty) Samson family is seen here in front of their home in 1914. From left to right are daughter Jean, son Jack, wife Betsy, and Scotty Samson with his dog. Scotty was a stonemason who came to Post in 1907 and built all of the stone buildings in town. He was a Scotsman and was dearly loved by all who knew him. He outlived his entire family, and all of the Samsons are now buried in Terrace Cemetery.

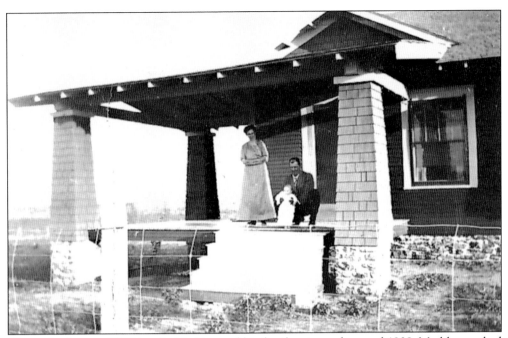

This is the home of William B. Markley and his family, pictured around 1908. Markley worked for C.W. Post. (Courtesy Bill Forrester.)

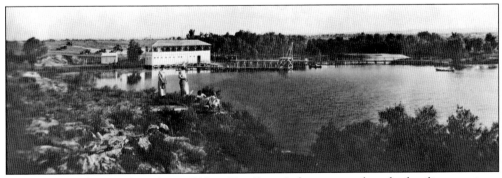

This photograph was taken about 1920 at Two Draw Lake, a great place for families to enjoy a picnic or do some boating and fishing. The boathouse and docks are large and look to be able to accommodate many boats and fishermen. Today the lake is still a great place to visit for the day or take advantage of overnight lodging.

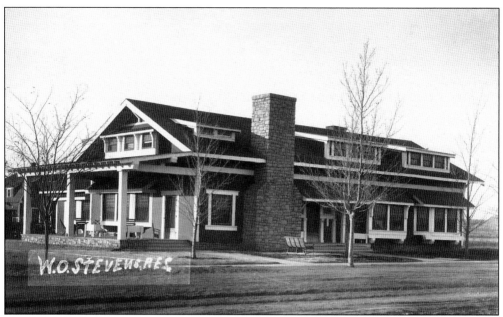

In 1913, this beautiful C.W. Post home was finished and ready to occupy. Post had taken his usual great care in the planning and building of the house, built in a California style. On the main floor is a large living room, servant's quarters, a library, a sun room and porch, a master bedroom for Leila and him, and three bathrooms. Upstairs were four guest rooms, a sitting room, and three bathrooms. Post already owned two fine country homes, one in Greenwich, Connecticut, and one in Santa Barbara, California. Later, the home became the residence of W.O. Stevens. Below is a view of the east side of the house. (Both, courtesy Jerry Stevens.)

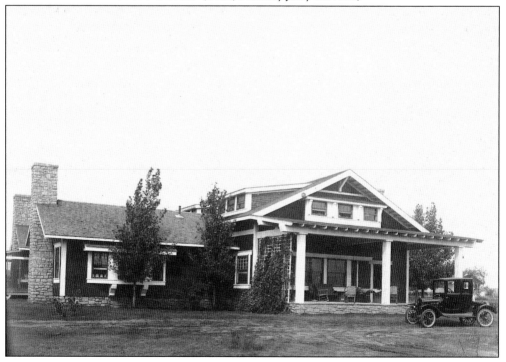

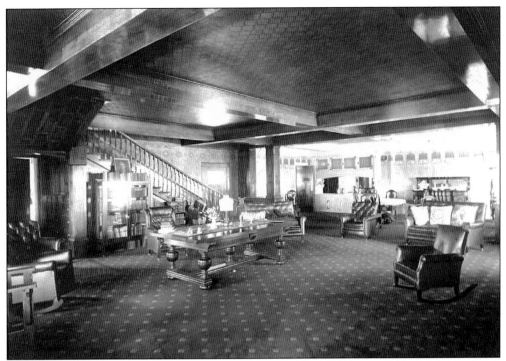

The interior of the Post home gives the viewer a good understanding of the vast living room, which he favored. A beautiful green Persian rug covered the floor. He personally selected the furnishing and the hand-painted leather wallpaper. The chairs were of stamped leather. Note the huge stone fireplace and mantelpiece. A framed portrait of C.W. Post sits on the right end of the mantle. The library table seen in the photograph below still occupies space in this beautiful room, now the grand room of the Hudman Funeral Home. (Both, courtesy Jerry Stevens.)

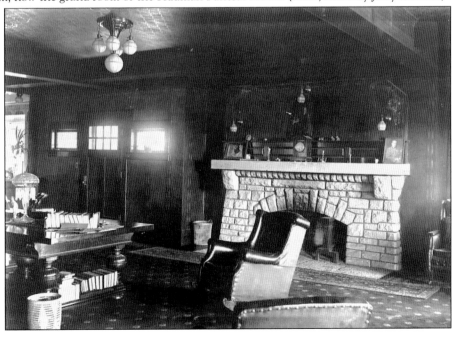

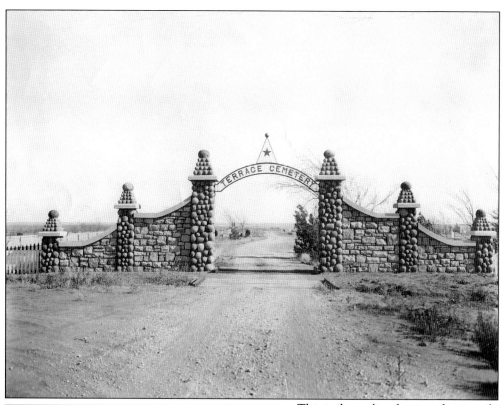

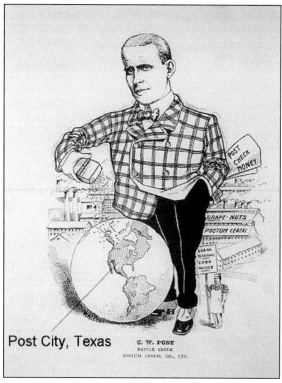

Post City, Texas C. W. POST
BATTLE CREEK
POSTUM CEREAL CO., LTD.

This is the earliest known photograph of the Post-Terrace Cemetery gate. It is built of native stone, including round stones donated by the Connells, owners of the OS Ranch, and the Slaughters, owners of the U Lazy S Ranch. The gate was built by George "Scotty" Samson and James Napier. The plans were drawn by Samson. Today, the cemetery has certainly grown, and it no longer has a white picket fence, but the stone gate is still there and sports a Texas Historic Marker. At left is a fun caricature of cereal magnate C.W. Post that highlights many of his accomplishments as he sprinkles Grape-Nuts around the world, especially in Post City, Texas.

Ruth Little was a very talented artist, business owner, and author of numerous books. She had a close relationship to the Graeber family, and some time after Minnie Graeber passed, Little purchased the family's two-story home and turned it into an apartment building. At her death, Little's daughter, Billie Ruth McCarty, donated the property to the Caprock Cultural Association. After extensive repairs and updates, it is now known as the Heritage House.

The Post Rotary Club was well represented at the 1936 Rotary Convention in Fort Worth, Texas. The meeting was held in the Cactus Room of the Texas Hotel there. From left to right are (seated) Phil S. Bouchier, John B. (Jay) Slaughter Jr., and Shorty V. Greenfield; (standing) Skeeter Slaughter, B.E. Young, and Bonnie Greenfield. There's Jay with his trademark cigar and six-shooter. Everyone has a hat except Young.

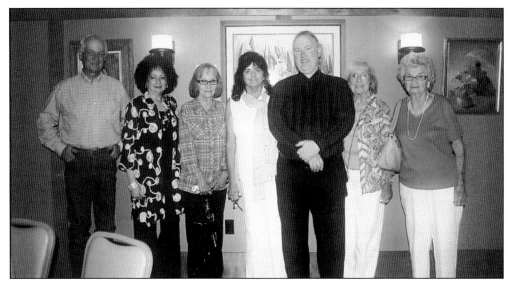

The Caprock Cultural Association hosted a 50th-anniversary party for the Post Art Guild. A few of the members are pictured here. From left to right are Ben Miller, Polly Cravy, Ann Bratcher, Linda Puckett, David Morrow, Marie Neff, and Sara Ault. David Morrow lives in New York but was in town in honor of his late mother, Glenda Morrow, and was the entertainment for the evening. He is a wonderful singer of opera and performs on Broadway in New York.

Ralph and Virginia Moody live in Battle Creek, Michigan. They are both retired from the Post Cereal Company. They are seated on the front steps of the Garza County Historical Museum in this 2007 photograph, with JoAnn Mock seated in the center. The Moodys own an extensive Post Cereal collection that is displayed at their own museum in Battle Creek. A large portion of that collection was loaned for exhibition during Post's centennial celebration, held in 2007.

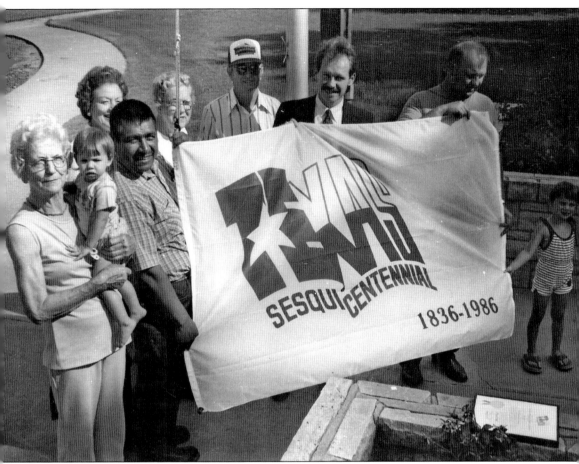

The Texas Sesquicentennial Celebration was kicked off by the raising of the flag at the courthouse. From left to right are Thelma Clark (holding Vondi Gradine), Pru Basquez, Maxine Earl, Margerite Hotaling, Donald Windham, an unidentified representative from Austin, Ronnie Gradine, and little Arimy Gradine. Thelma and Margerite are sisters and third-generation Garza County residents; Vondi and Arimy Gradine are fifth-generation Garza Countians.

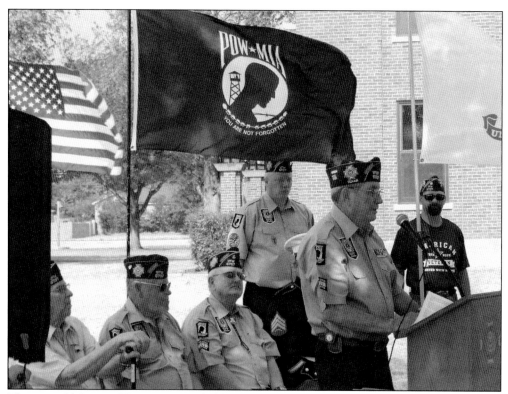

The annual Memorial Day ceremony held at the Garza County Courthouse by VFW Post 6797 features the new POW-MIA flag being displayed in 2010. From left to right are Marion Mathews, Joe Downs, Jimmie Howell, Richard Hinkle, commander Chuck Ratliff, and Steven Tidwell.

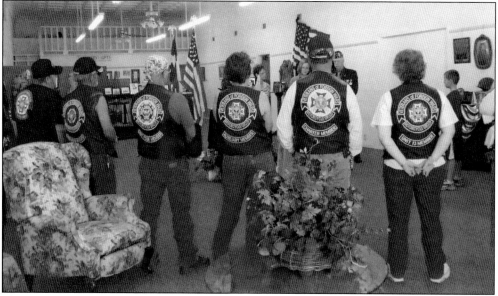

The Veterans of Foreign Wars Motorcycle Group arrived for the ceremony, which was held at the Algerita Arts Center. From left to right are J.W. Jolly, three unidentified (they rode over from the Midland club), Dal Davis, and charter member Rebecca Jolly.

Oil rigs and pump jacks are a big part of the landscape of Garza County and, in these two cases, in Post City. In the 1979 photograph at right, the rig is located behind the courthouse and towers over West Main Street. Below is a rare scene where Bond Operating Company has six pump jacks at work on the same site. A sign courtesy of Bond Operating Company and the Post Chamber of Commerce explains what is happening here. The diagram shows the pump jacks working multiple pay zones. (Both, courtesy Marie Neff.)

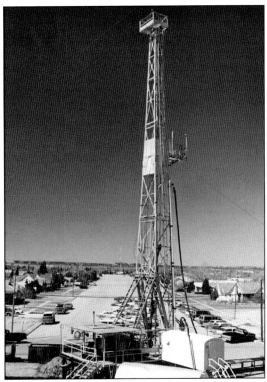

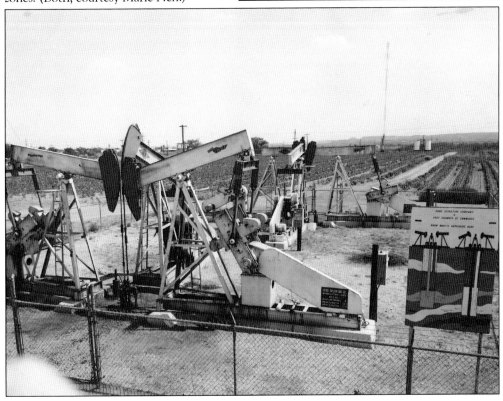

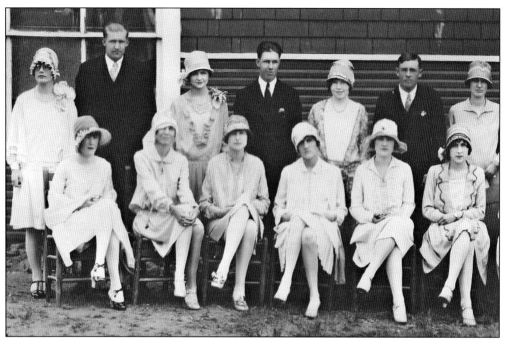

The 1920 graduating class of Post High looks like models or an acting troop headed for New York City. Above are, from left to right, (seated) Rosalee Smith, Lucille Collier, Helen Curtis, Dorothy Lee Speck, Ona Mae Stewart, and Mally Davis; (standing) Ethel Dent, Farris Bass, Beatrice Kirkendoll, Osca Brown, Ruth Manley, Homer McCrary, and teacher Altha Crunk. Below is also the 1920 graduating class of Post High School. From left to right are (seated) Morene Wall, Jewel Self, Henretta Foster, Opal Brant, and Verna Lee Brandon; (standing) Charles Louis Pickett, Ludell Crowley, Bud Speck, and Mary Texia Travis. Not in the photographs is Roy Brannon.

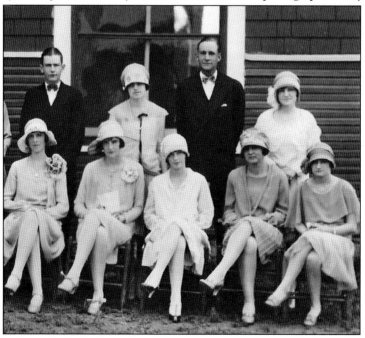

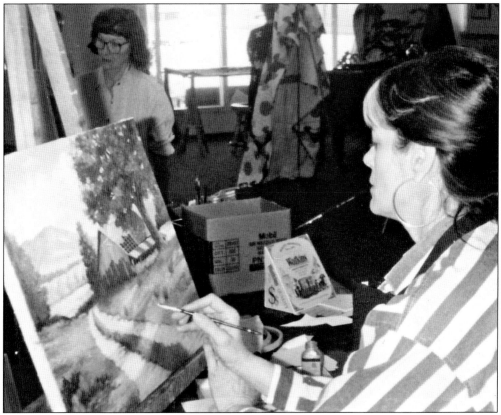

This 1990 photograph was taken at the Algerita Art Center as the Post Art Guild was conducting an art workshop with artist Robert Chennault. Ann Bratcher, a very talented artist, is seen here in the left background. Linda Puckett is the painter at right front. Below, Linda Puckett is conducting an art demonstration for a group of Post Elementary School students who are visiting the Algerita Art Center as a field trip.

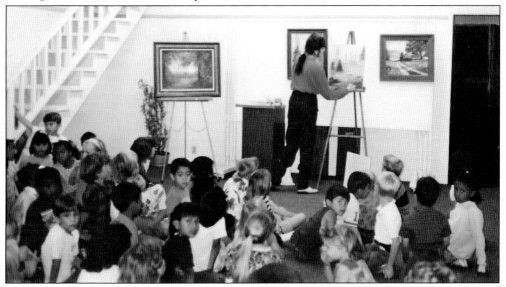

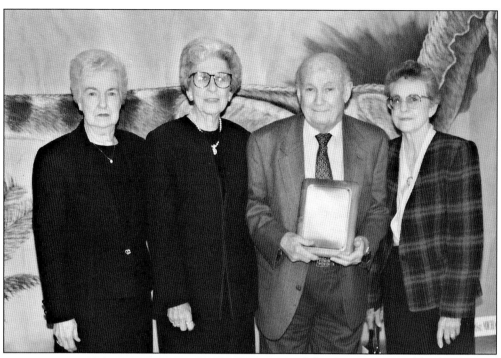

Giles C. McCrary and his lovely wife, Louise McCrary, are the couple on the right. It appears they have received the award for the OS Ranch Museum for Business of the Year. The two women at left are Gladys Blair (far left) and museum director Marie Neff. The McCrary Collection is one of the finest in the state of Texas.

C.W. Post was very well liked and respected by the men he hired to do a job, for in most cases, he would take off his jacket and barrel right in to help. In 1912, Idah McGlone Gibson was interviewing Post in Battle Creek when he made this statement: "I never give people anything, but put them in the way of getting what they want for themselves."

Five

STANDING ON THE PROMISE

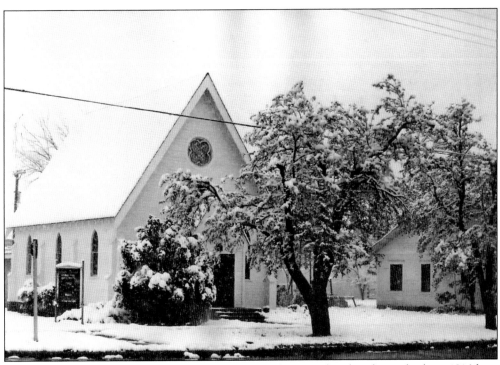

The Little White Church is covered in a blanket of snow. The church was built in 1916 by a small Presbyterian congregation who had been meeting since 1908. Their first pastor was Ralph Hall, well known as the "Cowboy Preacher." His salary was $100 per month. Later, when the Presbyterians built a new church, the Lutheran congregation acquired the Little White Church. Today, the church has a new congregation, the Cowboy Church.

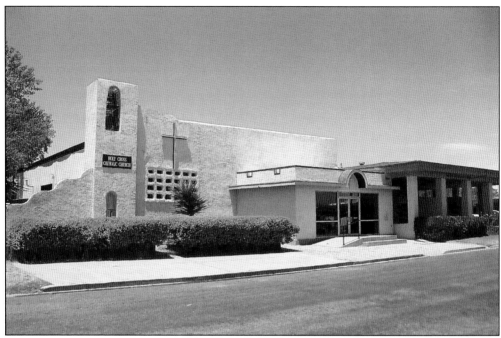

Holy Cross Catholic Church was established about 1955 in a garage. Father Erickson was the priest. In 1975, the church was moved to the old International Harvester building. Every year, improvements were made with the funds raised during the annual festival. The church celebrated its 50th anniversary in 2005. Fr. Hugh Thekkel is the current priest.

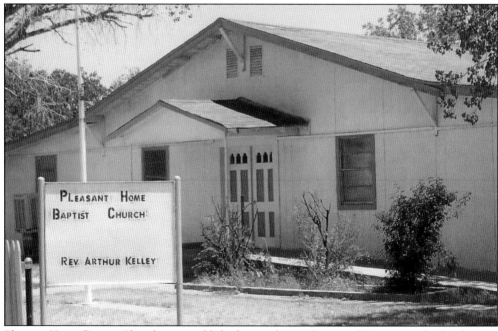

Pleasant Home Baptist Church was established around 1940. Reverend Frasier was the first known pastor, followed by Reverend Williams in the 1950s. Some time later, a Reverend Quinin was the pastor, and the current pastor is Rev. Arthur Kelly.

The First Christian Church was built and dedicated in 1934. In 1960, a new church on West Thirteenth Street and Avenue R was built. The new building was dedicated in 1961.

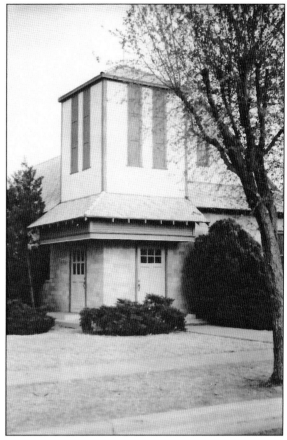

The Powerhouse Church was established in the 1950s by Mother Durham, who went into black neighborhoods to organize churches and find ministers to pastor the churches. E.L. Hastings was the pastor for Powerhouse; his son Jimmy Hastings succeeded him and is the current pastor.

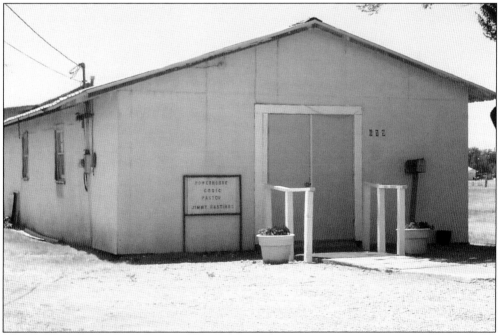

Calvary Baptist Church, as seen above, and Trinity Baptist Church, in the photograph below, are two Southern Baptist churches in Post. At one time years ago, the membership of Calvary experienced some dissension, and as a result, the congregation split. Half of the membership stayed on at Calvary, and the others spun off and built a new church in 1965, calling it Trinity Baptist Church.

Six
The Ups and Downs of Gettin' Around

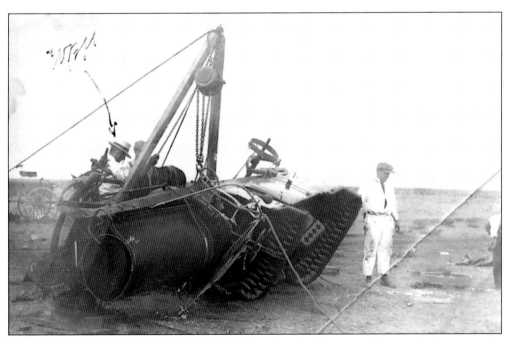

Jay Slaughter was cruising along on his way to Slaughter headquarters when, voilà, he was upside down. William Markley is looking over the damage with another fellow. It was a beautiful touring car before it lost a few wheels. Jay is standing there just glad to be alive. That block and tackle looks a little different from the wreckers used today.

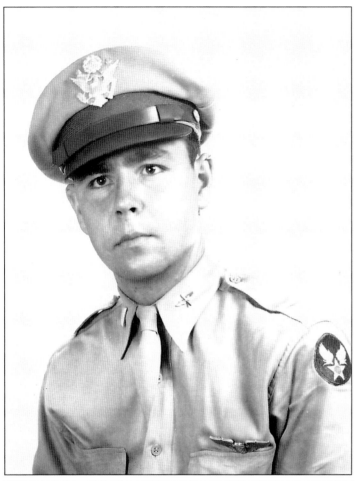

Stanley Butler was only 20.5 years old when he graduated from Aviation Cadet School with the Army Air Corps. He trained at Randolph Field at Pecos, Texas, along with 400 other cadets. He flew a DC-3/C-47 troop carrier, shown below, over every island in the Pacific. His cargo included everything from outhouses to lieutenant colonels. Butler left the Army in 1948, resided in Post, and went to work at the International House with Dale Mayfield. That building is now the Holy Cross Catholic Church. Stanley married Geraldine Cearley. In the photograph below, he and Geraldine are in San Antonio visiting and reminiscing with the old plane. The gentleman on the left is unidentified. (Both, courtesy Stanley Butler.)

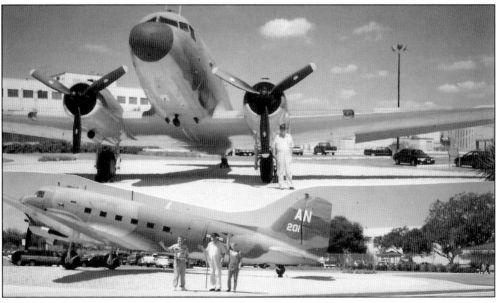

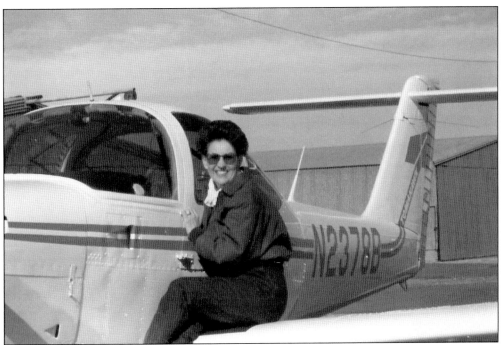

Marita Jackson is seated on the wing of her first plane, a 1983 Tomahawk. Soon she realized it wasn't fast enough. So in 1999, she purchased the 235 Cherokee seen below. It had a constant prop and would fly at high altitudes. The Cherokee was a four-seater with autopilot and wing fuel tanks. This was better—it would fly 150–200 miles per hour. She said that when her husband, Bo Jackson, made his first flight with her, she stopped at the end of the runway and asked him, "Are you scared?" He answered, "Are you?" She replied, "no." Off they went. (Both, courtesy Marita Jackson.)

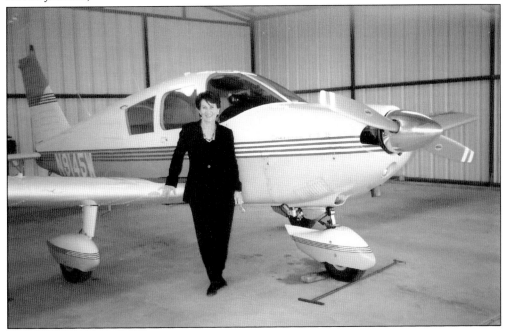

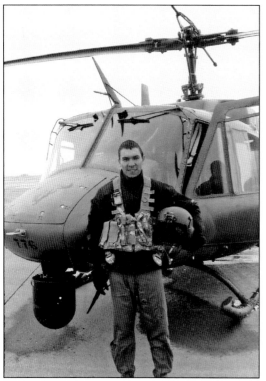

This is Capt. Clell E. Knight, US Air Force. Back home he might be called Little Buffalo Boy, a little half-Sioux boy who grew up on the Miller Ranch, making every step his grandfather Riley Miller made. They raised some buffalo on the ranch, and Clell, as early as five years old, was quick to school anyone interested on the value of a buffalo skull. Now he is out there burning up the skies with a buffalo skull on the nose of a Huey helicopter on missions protecting our country; or is he that same Little Buffalo Boy dancing on the edge of a lightning bolt to the sound of a Sioux drum? *Hanta Yo* (clear the way) Clell Knight, and God's speed to you and our fighting forces whose purpose is to protect us back home. (Both, courtesy J. Smith.)

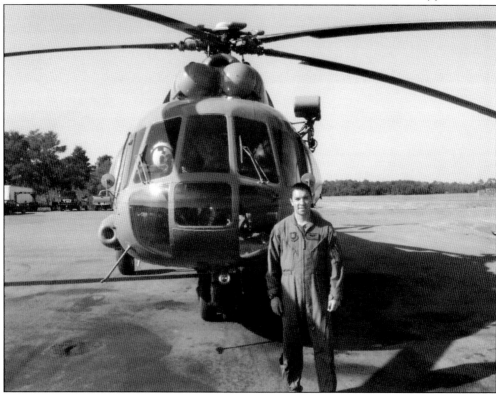

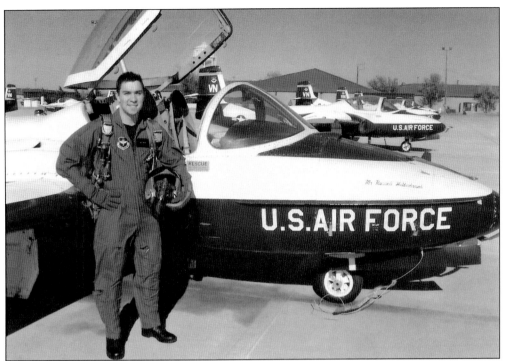

Capt. Clell E. Knight stands ready with helmet in hand beside a US Air Force jet with the canopy open and ready to take off. Below, he is flying the CV-22 Osprey, officially qualifying on May 1, 2012, and designated CV-22 pilot no. 125. The seal on his certification says "Air Force Special Operations–Anytime–Any place." What a statement this young man makes. (Both, courtesy J. Smith.)

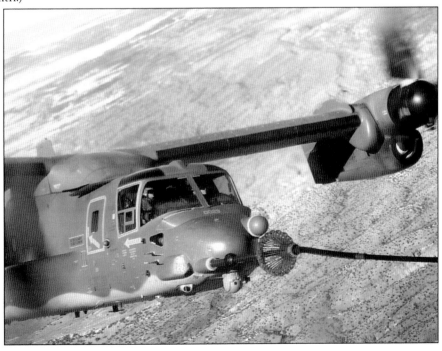

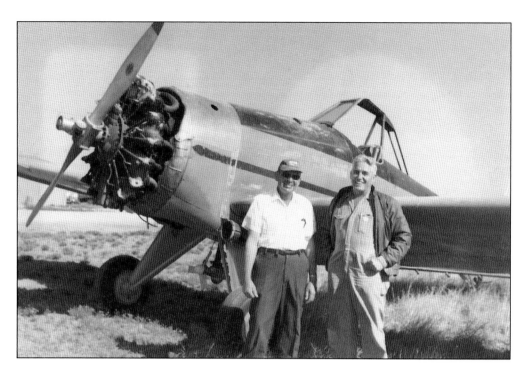

James Dooley owned many planes over the years. In the above photograph, he stands by his spray plane along with a Mr. Smith, a member of management at Burlington Mill. The photograph below shows Dooley standing beside an experimental plane that he built from scratch in 1998. (Both, courtesy Wanda Dooley.)

Ben Miller is pictured here with his Super Cub. There is not much that Miller doesn't do. He is a rancher, game hunter, painter, and sculptor, he sings, and he plays the guitar. Besides that, he is a real nice guy. Miller has been to several countries and on safari, but he probably never tires of flying over the landscape of the Miller ranch. (Both, courtesy J. Smith.)

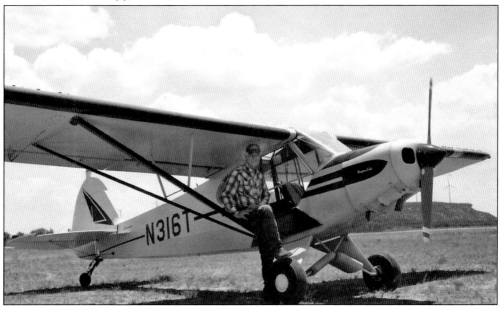

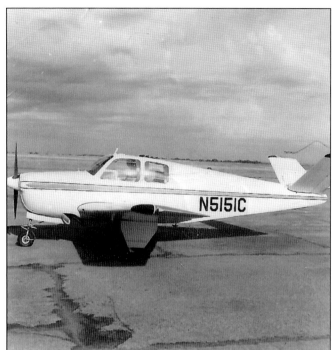

Corky Bullard is getting ready to take off in his plane. Corky says he acquired an old airplane without any wings, and he used to drive it up and down the alley. This is guy is pretty much a self-taught pilot. Some of the tales of him getting in a few tight spots lend new meaning to the old saying "learn while you're doing." By the way, the Bullards have a great vintage tractor collection. (Courtesy Bullard family.)

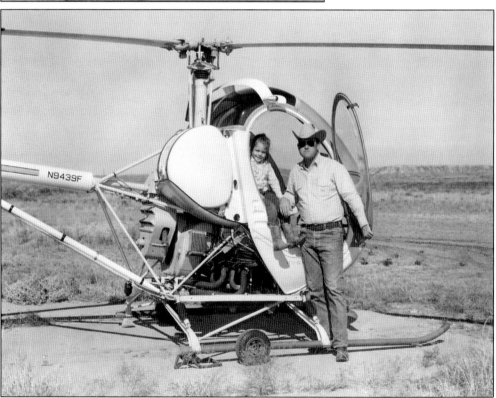

Bob Macy and daughter Charlotte pose at his Hughes 300 helicopter in 1970. Macy once said, "The helicopter is like a quarterhorse that can leap mountains, drive cattle, and hunt for strays."

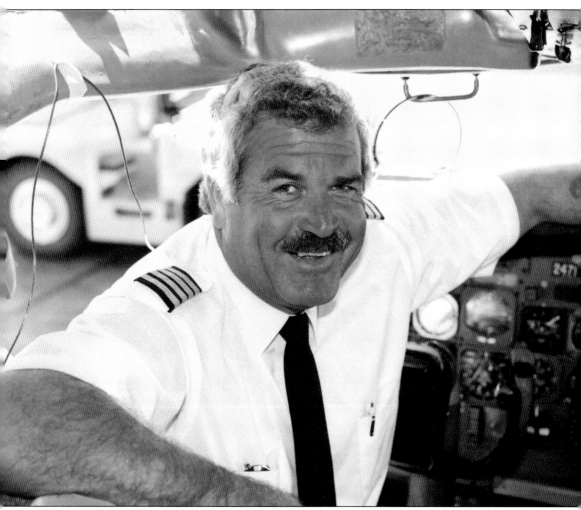

Paul Beach was born in California and raised in Las Vegas and on the family ranch in Garza County. He joined the Army in 1961 and was a member of the Special Forces. After his discharge, he completed pilot training and started flying commercially. He flew many different aircraft, such as the DC-3, Convair 580, DC-9, and Boeing 727. He retired as captain on the 727 after accumulating over 30,000 flying hours. In 2003, he moved to the Beach Ranch to operate it. Still having his love of airplanes, he obtained his A&P (aircraft and powerplant) and IA (inspection authorization) certification and continued to fly and maintain aircraft until his death in 2010.

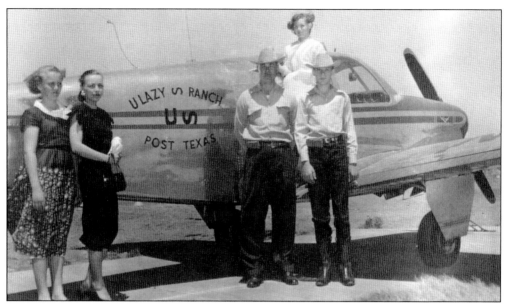

John Lott learned to fly in 1946 and purchased his first planes, a Taylor Craft and later a Stinson, which he kept until 1950, when he bought a Beechcraft Bonanza and a Piper Cub; both were for use on the U Lazy S Ranch. The Bonanza was used primarily for commuting and business trips to Fort Worth or Amarillo. In the above photograph is the Lott family; from left to right are daughter Patty Lott, Ryla Lott, John Lott, son John Jr. (Jack) Lott, and daughter Linda Lott (standing on the wing). Below, John is seen in the Super Cub. Note the microphone that allowed him to communicate with those on the ground, even the cows that he was running out the bushes. John Lott would fly right over the backs of the cattle. The ranch has its own landing strip about a half-mile from headquarters.

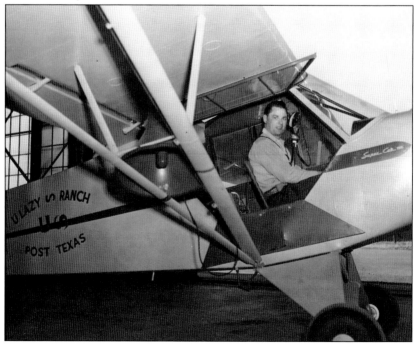

Charles Propst's regular job was working security for the government in Louisiana, Kansas, and Denver, and also for the Connell Estate. He was a pilot for many years and loved flying. Seen here are two of his planes. Before he became ill, he went out to the hangar, and when he returned, he handed wife Rheba the keys and the next day sold the planes. He knew and she didn't ask. (Both, courtesy Rheba Propst.)

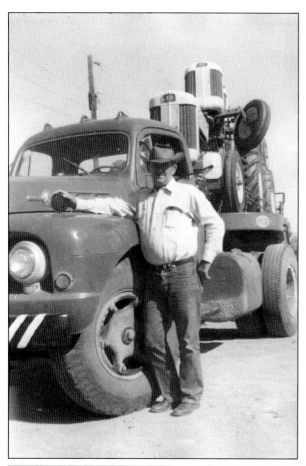

Basil Puckett was a farmer, rancher, and cattle hauler right up until the day he suffered a stroke in 1982 at the age of 76. He was a truck owner-operator for a good 40 years, hauling everything that needed hauling, especially cotton seed and cattle. In this 1951 photograph he's got on a load of tractors. He was one of the hardest working fellows a man would ever meet. That same work ethic rubbed off on son Tommy Puckett, who drove trucks for 54 years, retiring in 2011. Below is a 1986 photograph of Tommy Puckett, driver of this 1984 Peterbilt 600 truck.

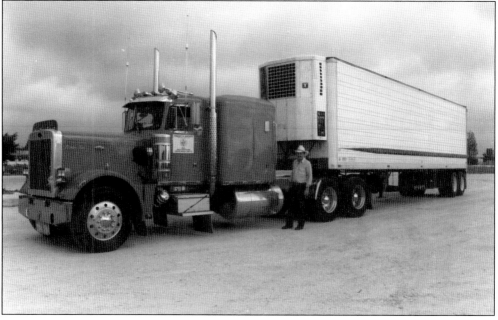

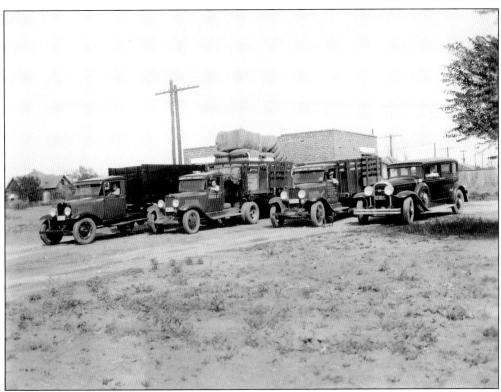

Arno Dalby started Dalby Motor Freight when he was just 18 years old when he bought a Model T truck. Dalby Trucking would evolve into a major trucking company called Time-DC, the nation's fifth-largest motor freight company. The gentlemen driving the trucks in the above late-1920s photograph are, from left to right, Allen Benton, Red Floyd, and Otho Collins. Delbert Dalby is driving the automobile. Below, a fleet of trucks is lined up on Main Street in Post, probably in the mid-1930s.

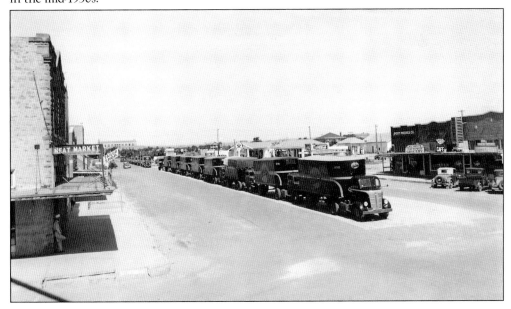

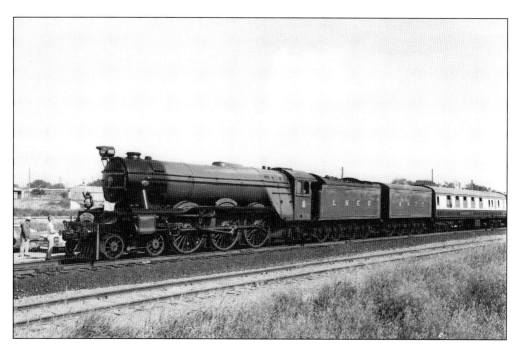

The *Flying Scotsman*, the famed 4472, was touring America in late 1968–1969. The train was built in 1923 as a steam engine capable of carrying nine tons of coal. It could travel long distances without stopping. In 1934, the 4472 became the first steam locomotive to be officially recorded at 100 miles per hour, earning a place in land speed records for railed vehicles. In 1968–1969, the train was brought to the United States to make a promotional tour. The photographs on this page are of the *Flying Scotsman* making a stop in Post at the train depot.

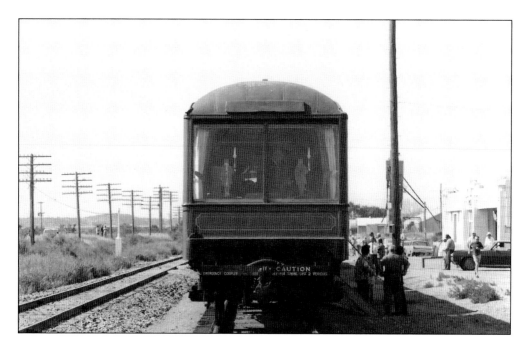

William Markley is seated in this 1908 REO. Automobiles were just appearing in West Texas and apparently were not very popular with some folks. On one occasion, the doctor from Fluvanna was being driven in his car over to Post City when he came up on a mule train on the roadway. The wagon boss drew his gun and ordered the dang noisy REO and its occupants off the road because they were the frightening the mules. These autos had two-cycle engines that could come down the Caprock at great speeds of 15 to 20 miles per hour. Going up was another matter. Below are C.W. Post (right) and Uncle Tom Stevens with Mr. Post's prize mules.

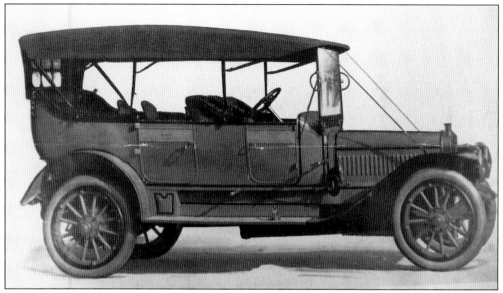

The Winston Six—a seven-passenger touring car—in the above photograph was owned by Mrs. E.B. Close (Marjorie Merriweather Post), the only daughter of C.W. Post. She and her husband, Edward Close, resided in Greenwich, Connecticut, but visited Post often through the years. The community Close City was named for her. Below is her father, C.W. Post, looking mighty dapper in this two-wheel, one-horse carriage. Both photographs are from about 1908. (Both, courtesy Bentley Historical Library.)

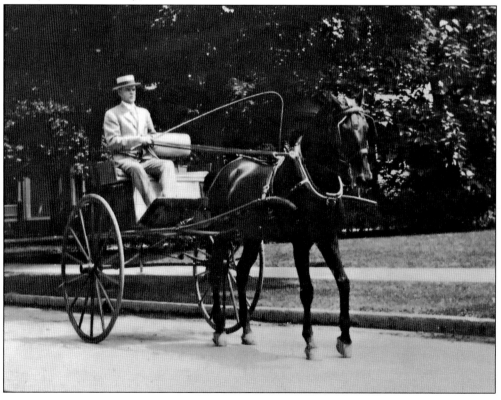

Seven
Post Sanitarium 100 Years Ago

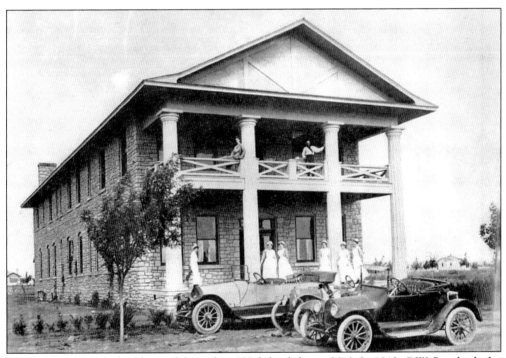

The Post Sanitarium building celebrated its 100th birthday in 2012. In 1912, C.W. Post built the hospital named the Post Sanitarium, a modern two-story stone building with 25 hospital rooms, furnished with the latest equipment and supplies necessary for the care of patients requiring medical or surgical attention. Its purpose was a place for people to go and become well. Dr. A.R. Ponton, chief surgeon, was at the helm.

Dr. Arnold C. Surman arrived in Post on June 11, 1913, on the Santa Fe train with a diploma from the University of Texas Medical School at Galveston, the top of his class in 1913. For the first six months, Surman's salary was $100 a month and board. The new doctors were quite proud of the facility, as nothing like it was to be found this side of Fort Worth. Patients flocked to the hospital from all over the area and even New Mexico. The staff of Post Sanitarium in the summer of 1916 included Ponton, Surman, and Dr. David Cash Williams, who joined them in 1914. Dr. G.G. Castleberry was the fourth member of the staff. The Surmans were members of the Presbyterian Church, and he was active in the Masonic Lodge. After Dr. Surman retired, he and his wife, Agnes, became active in the Historical Survey Committee; both enjoyed the experience of recording and preserving the history they lived.

Dr. David Cash Williams came from a family of doctors, his father and two uncles. He too had always wanted to be a doctor. After getting his bachelor of science degree at East Texas State and teaching mathematics for four years at Commerce High School, he left there and entered the University of Texas Medical School at Galveston, where he received his degree in 1913. After his internship at St. Mary's Hospital, he began looking for a place to live and practice his profession. He heard of an opening at Post through a school friend, Dr. A.C. Surman. Williams arrived in Post in 1914. When World War I broke out, he and Surman volunteered, and Williams was shipped to France, where he worked in a hospital for a year and a half. When Williams and Surman left for the war, chief surgeon Dr. Ponton moved on to Lubbock and built a sanitarium there. Dr. Williams was discharged in 1919 and returned to the area and eventually back to Post.

Mary Farwell, RN, as seen here in a 1918 photograph, was head nurse at the Post Sanitarium and also served on the Board of Directors of the Post Sanitarium Nursing School. Annie Cross, below, is one of the first graduates of the program. The school offered a three-year program, with the first year focusing on anatomy, physiology, and principles of nursing; the second year on medicine, diseases, and diet; and the third year on surgery, obstetrics, gynecology, and the eye, ear, nose, and throat. And then there was training for the nervous, the insane, and massage. At the expiration of the full term of three years, nurses passing the final examination received a diploma certifying their knowledge of nursing ability and good character.

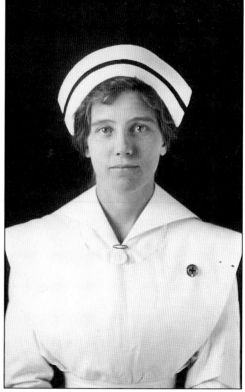

Harriet Baker also attended nursing school at the Post Sanitarium. She was the sister of Mrs. Harvey Dietrich of Post. Nurses in the program lived in the dormitory located next door.

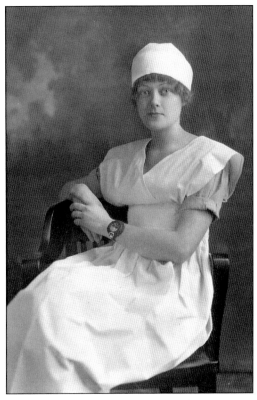

Scotty Samson, a stonemason originally from Scotland, built the massive structure from native stone brought in from the quarry. The building began with the planning in 1911. Building the two-story, 8,000-square-foot facility, including a basement, would be a major accomplishment considering that each and every stone was handcrafted using somewhat primitive tools consisting of hammers and chisels.

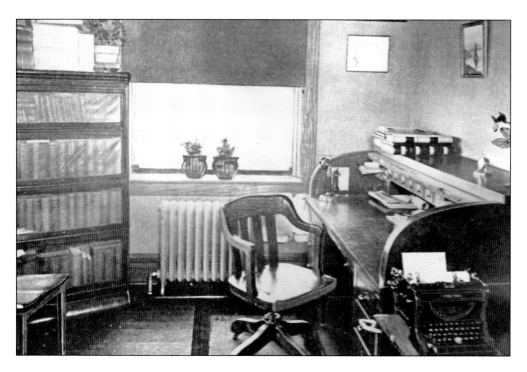

The doctor's office at the Post Sanitarium was located on the ground floor. Note the steam radiator. The Garza County Historical Museum has in its collection that same desk chair belonging to Dr. Surman, his typewriter, and diplomas and medical books as well. Below is the dining room. The floors were of stained pine, and in this room was a Persian rug that added to the atmosphere.

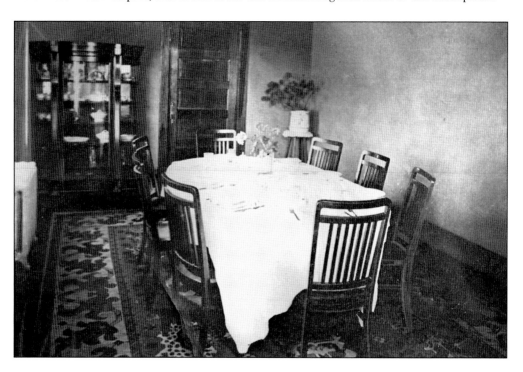

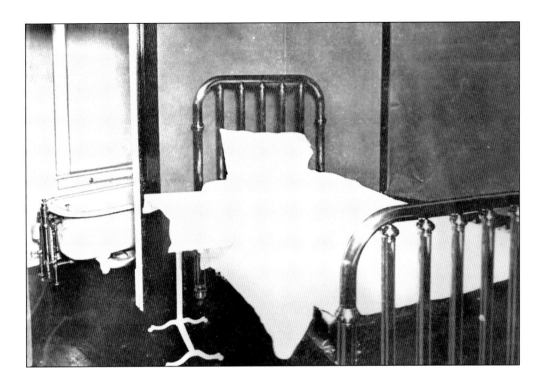

The above photograph shows a private room in the hospital; each was complete with a full bath, which included a footed tub, and a closet. There were two wards with multiple beds, as seen below. Women were on the south side of the hall, and men were across the hallway.

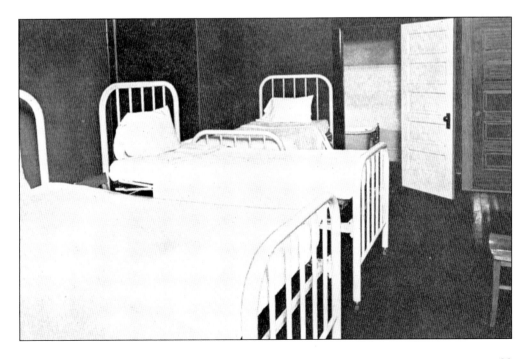

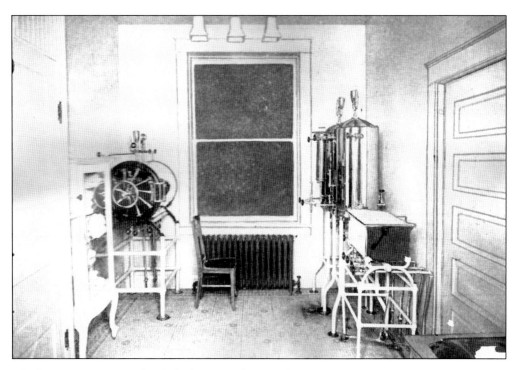

The hospital was equipped with the latest machines and supplies necessary for good health care and surgeries. Note the tile floor and the operating room pictured below. Some of the original equipment is in the museum collection. The skylight and tile floors remain today, 100 years later.

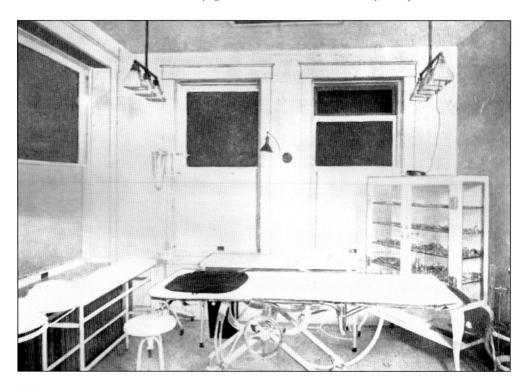

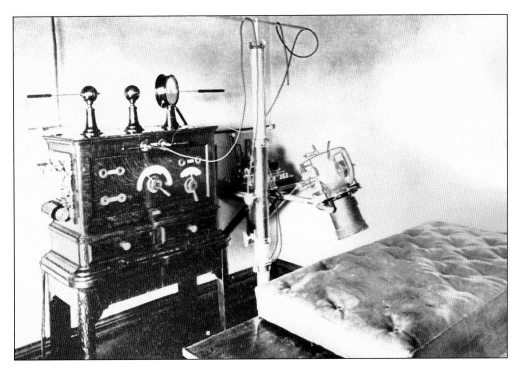

The top photograph shows how an x-ray machine looked in 1913. The film was developed under the stairway. Below is the lab. Specimens line the wall shelves, and note the microscope on the table. This may look like primitive medicine, but for the time, it was quite advanced. The hospital had the convenience of complete bathrooms with flushing water toilets, electric lights, and steam heat.

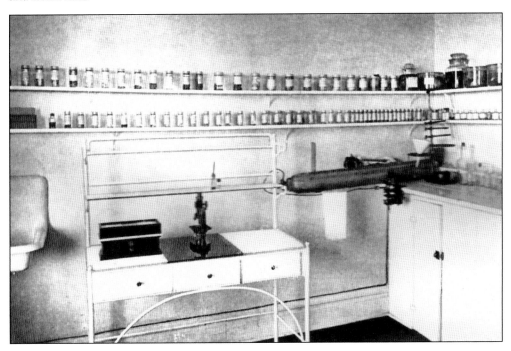

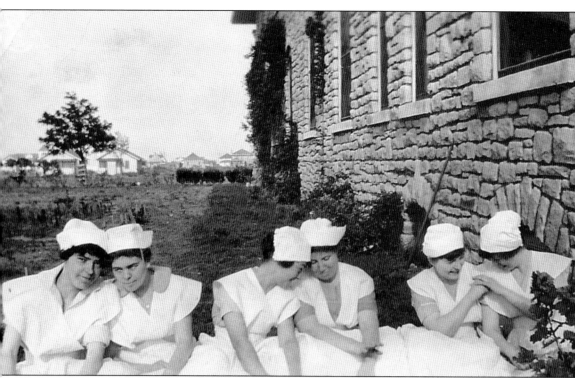

These young ladies are nurses enrolled in the nursing school at the Post Sanitarium. The back of the photograph, dated 1917, indicates they had sent it to a soldier named Irvin serving in World War I. Apparently Irvin made it back safely, and so did the photograph that was supposed to scare off the animals while he was in the trenches. Sadly, some time after 1918, the hospital closed. The doctors were abroad serving in the military as medics. When they came home, the cost of running the hospital was far too much for two young doctors who had very little money. Dr. Surman and Dr. Williams did open a joint practice in an office downtown. Some time later, the sanitarium became the Colonial Apartments, and eventually, the Mason family who owned it donated the property to Garza County for use as a museum. The building has two Texas Historic Markers and is listed in the National Register.

Eight
C.W. Post Historical Center

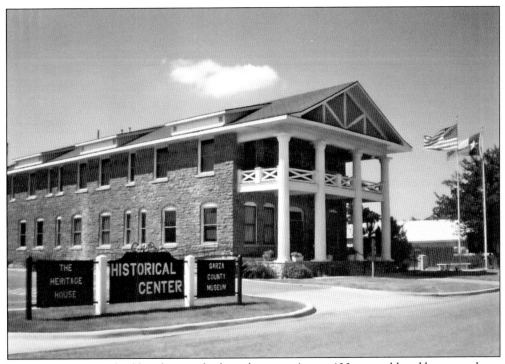

The Old Sanitarium building has reached a milestone; it's now 100 years old and has never been in better shape than it is now. The Mason family had the forethought to donate this landmark to the county for use as a museum; that was a very good thing. Much has happened with the building over the last two decades. The 8,000-plus-square-foot building has evolved, taking on a life its own as a conservatory of the history of Garza County.

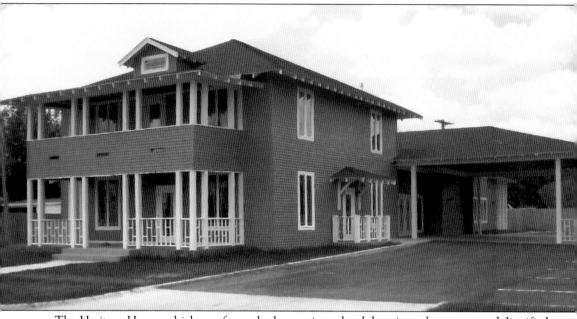

The Heritage House, which was formerly the nursing school dormitory, has a new and dignified look. And the interior is just as wonderful. Don Collier and Texas Tech University teamed up on this project with phenomenal results that will last for many years to come. If someone has a wedding or other special event coming up, this is the place.

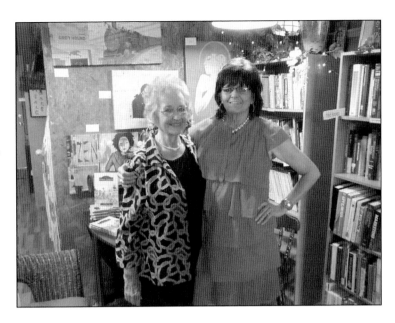

JoAnn Mock (left) and author Linda Puckett are pictured at the Ruby Lane Book Store in Post in 2010. Puckett's new book, Images of America: *Garza County*, had just been released, and the store was hosting a book signing. This was an exciting time for families, many of whom were descendants of people featured in the book, and certainly for Puckett.

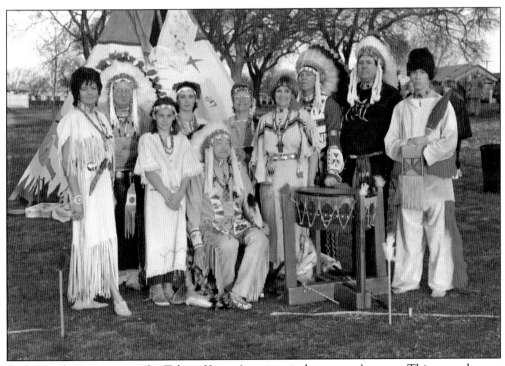

Each March 22 at sunrise, the *Tabana Yuane* (sunrise wind ceremony) occurs. This annual event is conducted to discern the direction of the wind exactly at sunrise on the morning following the first day of spring. This ceremony has been a tradition since around 1906. From left to right in this 1997 photograph are Linda Puckett, Ken LeBlanc, Sarah Kirkpatrick, Jayda Cravy, Chief Frank Runkles (seated), Shirley LeBlanc, Zoe Kirkpatrick, Jack Ramey, John Cory, and Mike Cory.

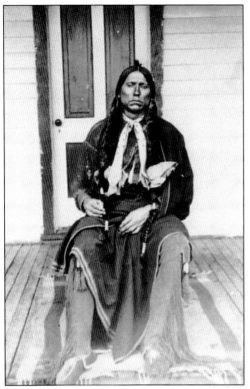

This photograph of Comanche chief Quanah Parker was possibly taken just after Quanah surrendered his Quahadi warriors at Fort Sill, Oklahoma, in 1875. This porch resembles the one on Star House in Cache, Oklahoma, that was built for the warrior and his five wives. (Courtesy University of North Texas Libraries.)

On the grounds of the Garza County Historical Museum stands a giant arrow marking the Quanah Parker Trail. Two Garza County employees are busy working on the landscaping and walkway leading to the arrow. On the left is Oscar Lopez, and Lupe Perez is at right. These guys keep the grounds and help with dozens of other deeds.

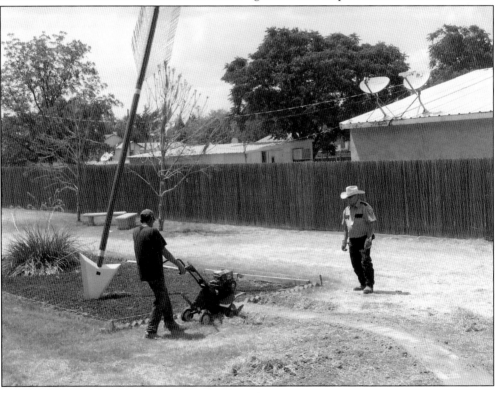

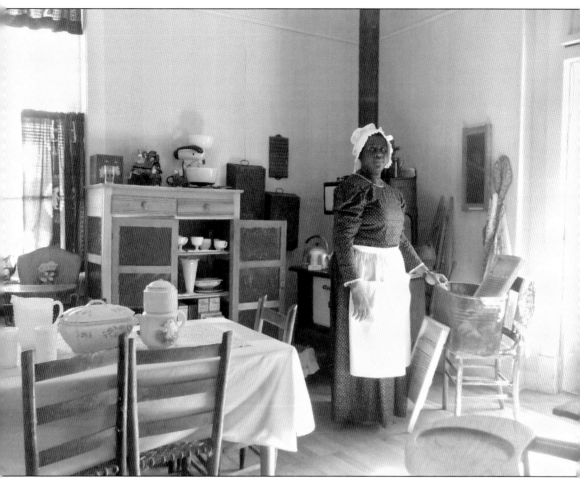

Patricia Cruse stands in the vintage kitchen at the museum preparing for her role as Sojourner Truth. Pat is about to perform her "Trunk Show" presentation, a one-woman show that she puts on for various clubs and schools in the area. This is a perfect role for Pat, as she has done extensive research over the years on the life of Sojourner Truth and the part she played in the Underground Railroad and her association with Pres. Abraham Lincoln.

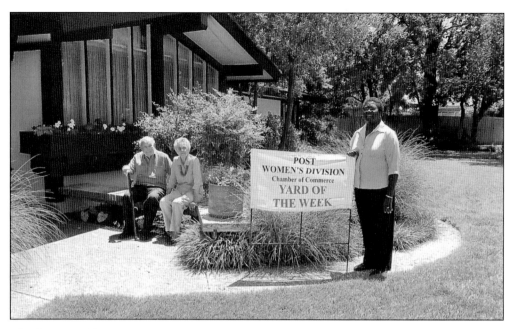

This book would not be complete without remembering Giles C. McCrary as he was just a short time ago, sitting in the yard with his lovely wife, Louise McCrary. Pat Cruse is there to install the Women's Division sign for Yard of the Week. Giles McCrary is greatly missed by all. And in the photograph below is Mike Mitchell, who also left us quite suddenly. He was a super fun guy and is greatly missed. They are gathered at the Garza County Courthouse for the Centennial Celebration in June 2007. Sitting above are Rex and Terri Cash; sitting in chairs are Barry Morris (left), Wanda Mitchell, and her husband, Mike Mitchell.

The Alvin Davis Collection at the museum represents a lifetime of promoting Western heritage. Alvin and Barbara Davis are unique individuals who have shared so many common goals, and both have received hundreds of awards documenting their achievements. In 1948, Alvin put together an All Kid Rodeo. That was not a one-shot deal but the beginnings of a program that evolved into the American Junior Rodeo Association, which marked its 60th anniversary in 2012. Alvin is standing beside the 50th-anniversary saddle and cedar saddle stand presented to him in 2002 at Sweetwater, Texas. Below, one can see the cover of the book *Post City, Texas*, by Charles Dudley Eaves and Cecil Alan Hutchinson. The photograph shows bullfighter Gary Puckett.

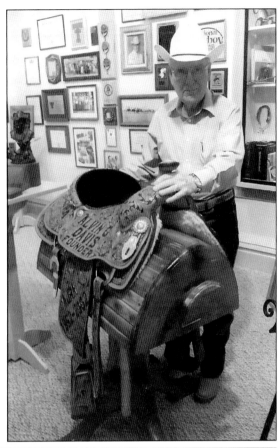

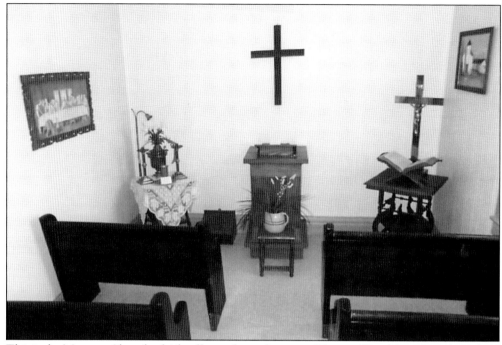

This is the Museum Chapel, which offers a place of serenity. Two small weddings have been held in the little chapel over the last few years. The pews are handcrafted, as is the lectern that was used in local churches.

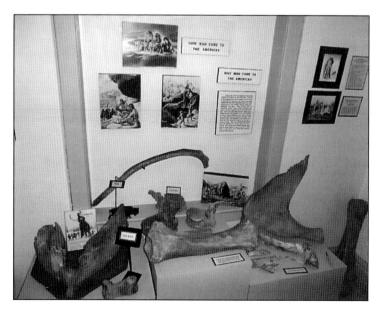

When Bruce Ledbetter and his friends left the house one day to go to a swimming hole, they had no idea that they were about to make a major find. A big rain had partially uncovered the remains of three woolly mammoths. Initially what they saw was the large hip bone protruding from the ground, as seen on the right. Digging deeper, they discovered vertebrae, ribs, jawbones, teeth, and tusks.

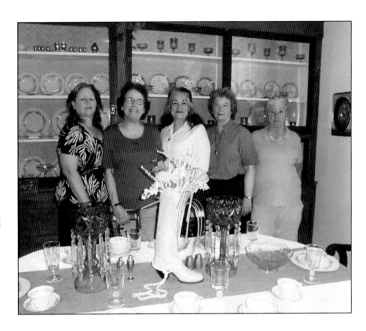

Cook family cousins dropped by the museum to view items from their family that are on exhibit. Mr. and Mrs. O.R. Cook were honored by the Post Chamber of Commerce back in 1949 for having 11 children who all graduated from Texas Tech University. They all served in various branches of the military, even the girls. Two of the 11 were enrolled when Tech opened in 1925. Seen here are, from left to right, Sandy Sweeten, Evelyn Walsh, Suzzan Nutting, Charlotte Morse, and Carolyn Cummings.

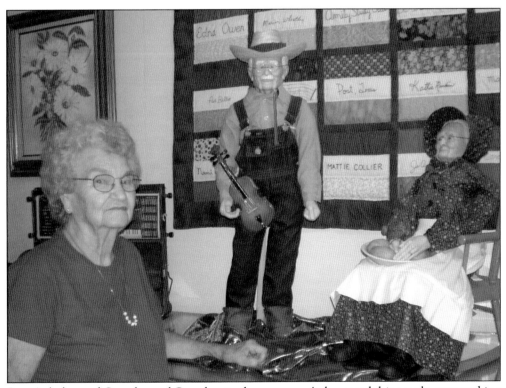

Sara Ault donated Grandpa and Grandma to the museum. Ault created this couple, even making their clothes. She received numerous awards at the county fair and local shows. Sara and her late husband, Jack, are past members of the museum board of directors.

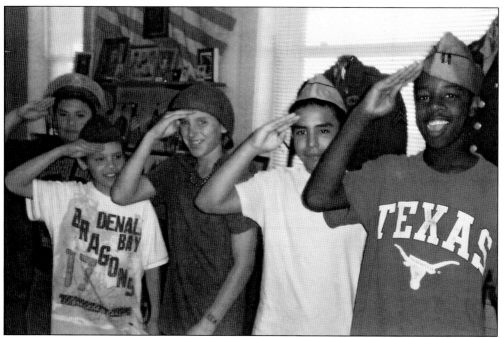

Post Independent School District sixth-graders go on a field trip to the Garza County Historical Museum. The young lads in the above photograph look as though they have that salute mastered, pretending to be in the Army now, but they still have a few years to wait. Below, with their lists in hand, the students begin a scavenger hunt.

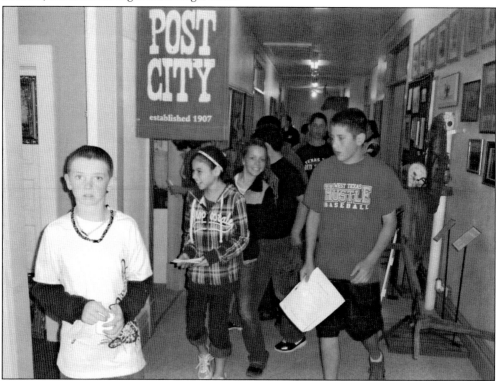

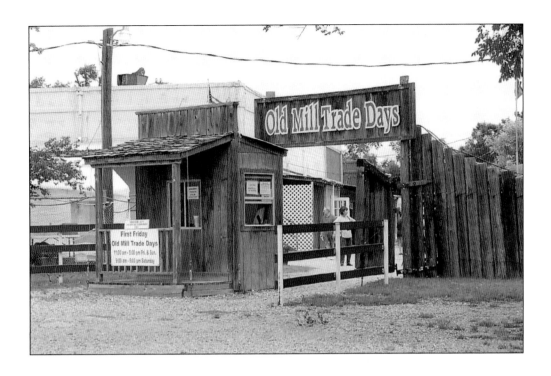

Old Mill Trade Days were always held on the first weekend of each month. During peak months, sometimes 10,000 people would pass through those gates over Friday, Saturday, and Sunday. The whole town would be in a festive mood, with great shopping, good food, and entertainment.

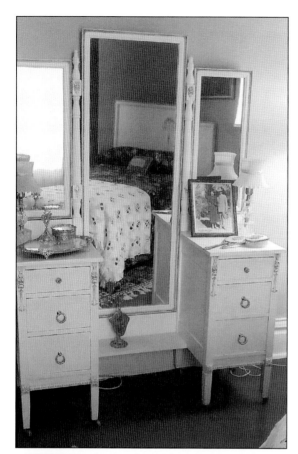

Sylvia Winder was born in Post, Texas. Her father built the first cotton gin in Close City. Winder donated her parents' 1940s bedroom suite to the museum. The cute little girl in the photograph on the night stand is Sylvia when she was about seven. When she is in town, she always drops by for a visit and a walk-through and to do some reminiscing.

The National Cowboy Symposium is a great place to show off the town's "stuff" and is really a celebration of new and old friends. Below, Pat Cruse snaps her fingers to the music of one of the performers playing the harmonica, Ludie Stone of Amarillo. And there is Dolores Mosser from Texas Plains Trail taking a moment to read Linda Puckett's book Images of America: *Garza County* and peddling her own book, *A Train Story*.

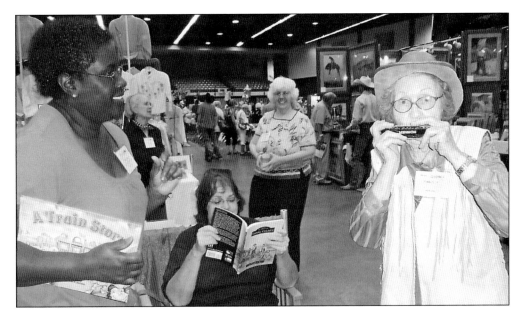

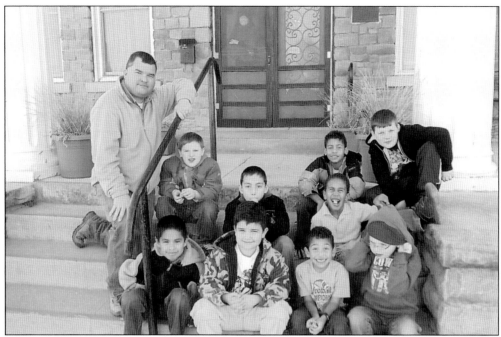

Here are Richard Hudman and his Cub Scouts sitting on the steps of the museum. First names only, they are, from left to right, (first row) Roger, Nick, Joey, and Kohen; (second row) Damon, Cruz, Michael, Javon, and J.R.

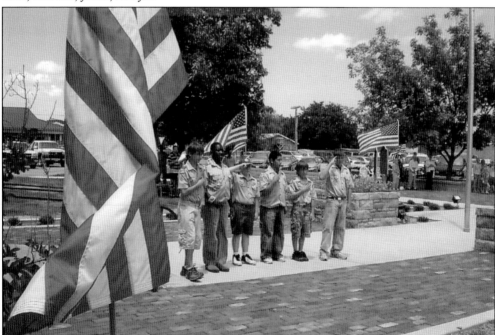

In 2007, Post celebrated its 100-year anniversary. The final day of activities was held at the Garza County Courthouse with the dedication of the new brick Memorial Plaza. Shown here are local Boy Scouts saluting the flag. From left to right are Dalton Thuitt, Jaden Wiseman, Caelan Thuitt, Eliza Garza, Raden Babb, and Zack Hinkle.

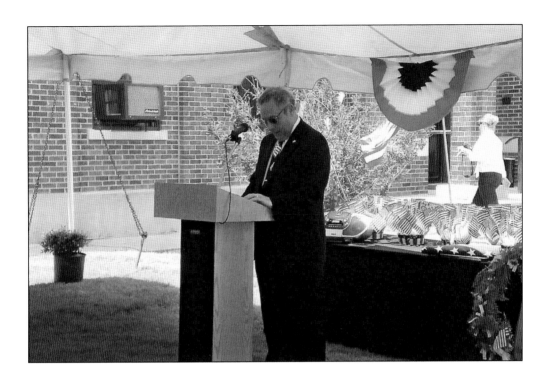

The Centennial Celebration continues with Garza County judge Lee Norman at the podium. Below is Giles McCrary Jr., who is documenting the event. McCrary also filmed and produced the centennial documentary *Post City*.

Here is showcased just a sample of the museum exhibits. Above is a collection of Maxine Durrett Earl. She belonged to several local clubs and loved to entertain using many of the items shown here. Below are "Miss Ruby's Hats," which belonged to the late Ruby Kirkpatrick. Both ladies were matriarchs of the community.

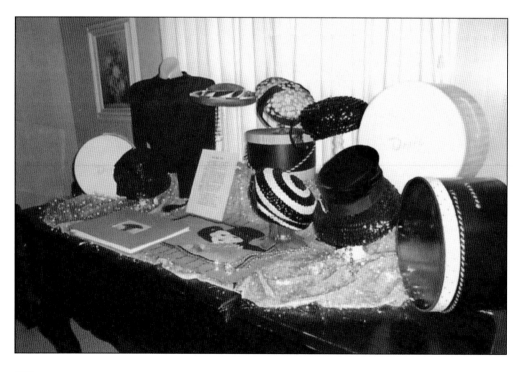

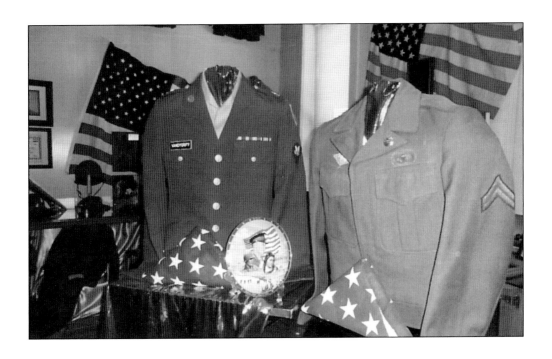

It is such an honor to present a collage of memories, photographs, uniforms, and artifacts that tell the story of the men and women of the immediate area who wear the uniform and fight the battles for not only our freedom but the freedom of people around the world.

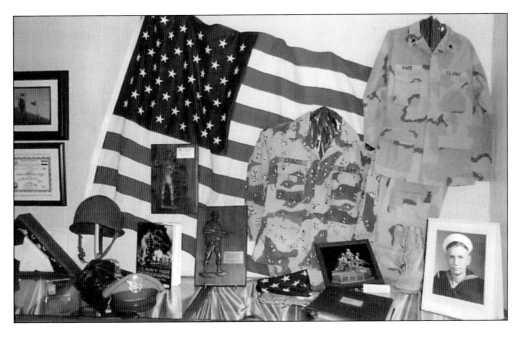

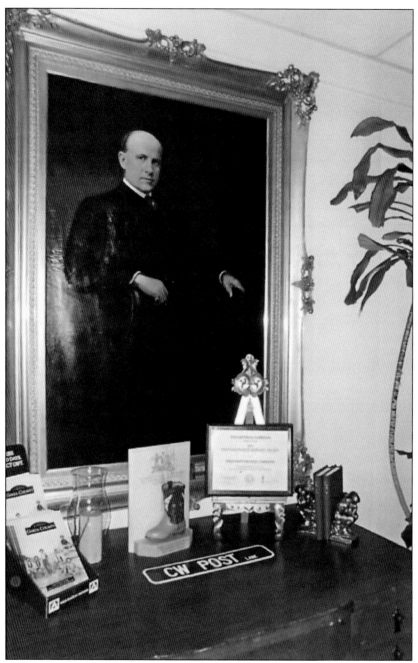

Charles William Post founded Post City, Texas, in 1907. In 1912, the newspaper reporter Idah McGlone Gibson asked Post what was his secret for success. "Great Scott!" he exclaimed, "There is no secret about it. It's keeping everlasting at it—the stick-to-itiveness and belief in oneself, which can put one's wildest imagination to the test. One of the things I have never been able to understand is why anyone would consider that Adam and Eve were cursed with work when they were turned from the Garden of Eden. Then and there was conferred on them, and those who came later, the greatest of blessings. Work is the great panacea for grief, the conserver of life and surety of success. I have worked all of my life and expect to keep on working until I die."

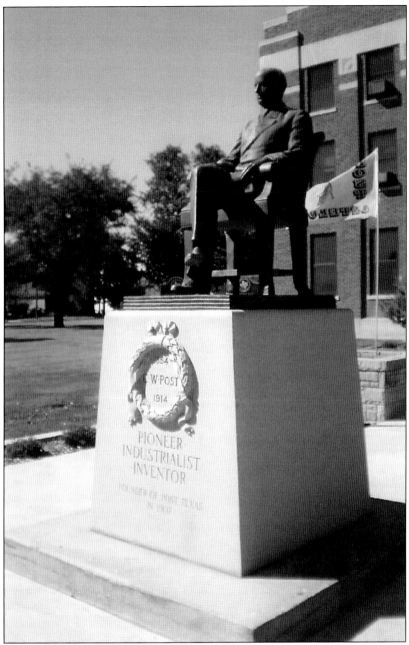

Here sits C.W. Post looking east down the main street of the city he built in 1907. He accomplished so much in seven short years. He would be most proud of the people of Post and Garza County for what they have accomplished in the last 100 years. In 1912, he said: "I have always made money and spent it like the proverbial drunken sailor. I have never cared particularly for money except to use it. I remember when I was in my twenties I made $40,000 in a deal and lost it in another without ever seeing an actual penny, and I did not worry over it a minute. I suppose the story books will say 'Post laid his cornerstone of his wealth when he began to cook his breakfast food in an unusual carriage house.' I, however, did not consider it the cornerstone of my wealth, but my health."

Kenneth Marts was foreman at the Double U Ranch for many years. This photograph was taken on the last day of the Double U ranch operation, December 31, 1995. That day closed a chapter but opened another for Marts, for now he runs his own ranching operation and still lives just beyond this sign that reads Double U Ranch.

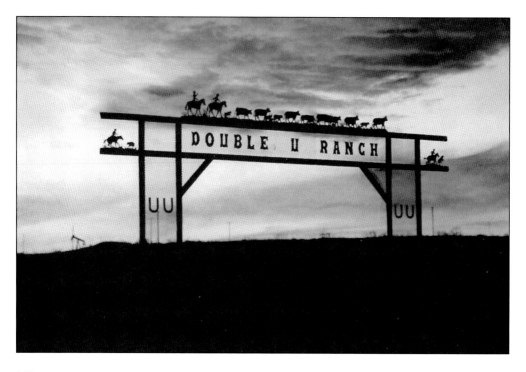

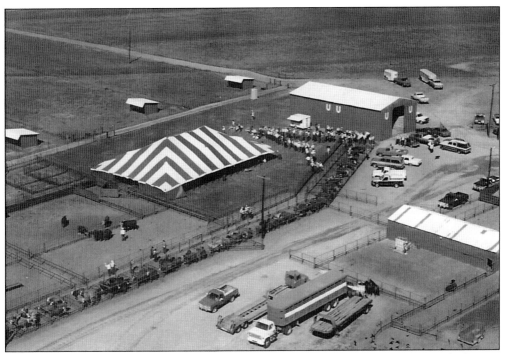

The red UU barns always grab the attention of everyone driving down Highway 380. The famous annual UU bull sales were always held here. If one was lucky, he or she would be invited out to have lunch that consisted of lots of brisket with all of the trimmings. Everyone had a great time, and locals had a chance to visit with all the Post-Montgomery families. Below, the guys are hauling supplies with the chuck wagon.

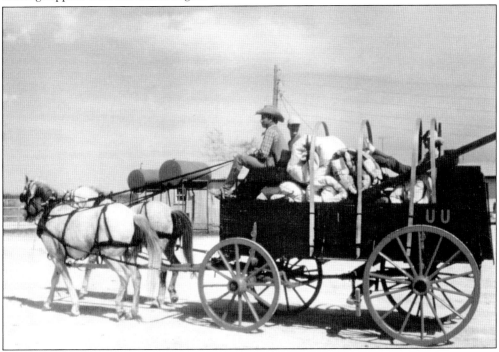

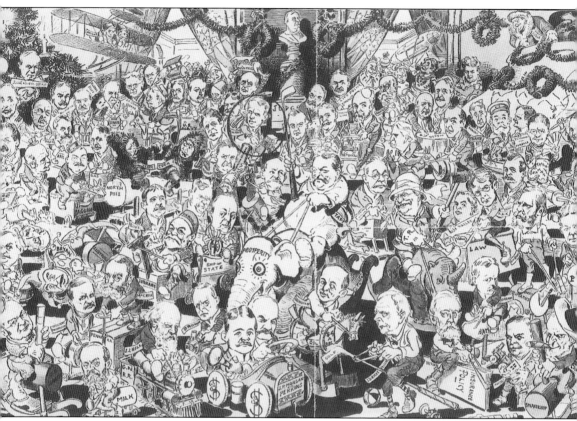

This c. 1912 caricature represents a "who's who" of the elite at Christmas—C.W. Post is circled. Named alphabetically are Felix Angus, Nelson Aldrich, J.D. Archibald, J.O. Armor, J.W. Dailey, R.A. Ballinger, James Bennett, Albert Beverage, Frank Black, Anthony Bradley, W.C. Brown, Wm. Bryan, T.F. Burton, Joe Cannon, Andrew Carnegie, J.C. Clarkson, Dr. Cook, W. Murray Crane, Glenn Curtis, C.C. Davis, C.M. Depew, J.M. Dickson, John Dryden, J.W. Dwight, Edward of England, Chas. Fairbanks, H.C. Frick, Wm. Hurst, D.B. Hill, J.J. Hill, Frank Hitchcock, Clark Howell, Chas. Hughes, Darwin Kingsley, Philander Knox, Wm. Lamb, R.S. Lovett, J.L. Maldin, James McCrae, Geo. Meyer, J.P. Morgan, Paul Morton, Frank Munsey, Chas. Nagle, Nicolas of Russia, Alton Parker, R.E. Peary, B. Penrose, Geo. Perkins, C.W. Post, Frank Presbrey, Herman Ridder, John D. Rockefeller, Wm. Rockefeller, Theodore Roosevelt, E. Root, Thomas Ryan, Frank Seaman, Jas. Sherman, Henry Stockford, M. Stone, N Strawn, John Stubbs, Wm. Taft, Chas. Taylor, D.L. Taylor, J. Walter Thompson, Wm. Trucedale, Samuel Untermeyer, Geo. Van Clove, Henry Waterman, Geo. W. Wickersham, William of Germany, and Wilbur Wright.

Jim Nolan arrives at the Garza County Historical Museum aboard his J. Brown stagecoach, lined with 14-carat gold and built specifically for the Pres. George Herbert Walker Bush Inaugural Ball. The coach is pulled by matching Perchaner molly mules trained by the Amish in Kansas. Nolan is the owner of Rafter J. Exceptional Rodeos for disabled and handicap children.

The award in the photograph at left represents a proud moment for the Garza County Historical Museum Board of Directors, the Garza County Commissioner's Court, and most of all the museum's staff, Linda Puckett, director, and Patricia Cruse, director's assistant.

We hope you have enjoyed learning about Post City, Texas. We cordially invite you to visit our community and the Garza County Historical Museum. For more information contact Linda Puckett, executive director/curator, at 806-495-2207 or lgpuckett@gmail.com or garzamuseum@yahoo.com

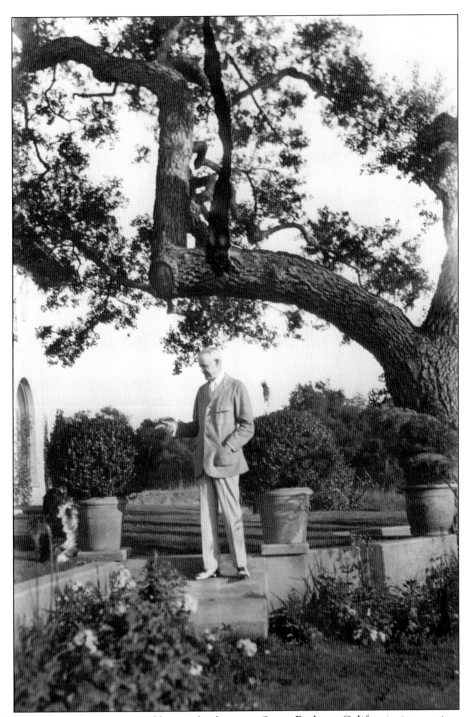

Charles William Post is pictured here at his home in Santa Barbara, California, interacting with his dog. Post died here at home on May 9, 1914. A country grieved the loss of an American icon. Just a year prior, in March, he wrote these words to his company managers at the Double U Company. "I have raised the child [Post City, Texas] on the bottle up to the time when it should be weaned, and that time is now."

Discover Thousands of Local History Books
Featuring Millions of Vintage Images

Arcadia Publishing, the leading local history publisher in the United States, is committed to making history accessible and meaningful through publishing books that celebrate and preserve the heritage of America's people and places.

Find more books like this at
www.arcadiapublishing.com

Search for your hometown history, your old stomping grounds, and even your favorite sports team.

Consistent with our mission to preserve history on a local level, this book was printed in South Carolina on American-made paper and manufactured entirely in the United States. Products carrying the accredited Forest Stewardship Council (FSC) label are printed on 100 percent FSC-certified paper.